HOW TO DRAW
THE CHARMING
AND ROMANTIC
CHARACTERS OF
JAPANESE COMICS

MANGA MANIA
SHOWJO

CHRISTOPHER HART

WATSON-GUPTILL PUBLICATIONS/NEW YORK

To my readers, for whom these books are written. I hope that you not only learn from this tutorial but are inspired to create.

Senior Editor: Candace Raney
Project Editor: Alisa Palazzo
Designer: Bob Fillie, Graphiti Design, Inc.
Production Manager: Hector Campbell

First published in 2004
by Watson-Guptill Publications
a division of VNU Business Media, Inc.
770 Broadway, New York, NY 10003
www.watsonguptill.com

Copyright © 2004 Star Fire, LLC

Library of Congress Cataloging-in-Publication Data
Hart, Christopher.
 Manga mania shoujo : how to draw the charming and romantic characters of Japanese comics / Christopher Hart.
 p. cm.
Includes index.
 ISBN 0-8230-2973-5 (pbk.)
 1. Comic books, strips, etc.—Japan—Technique. 2. cartooning—Technique.
3. Comic strip characters. I. Title.
 NC1764.5.J3H36938 2004
 741.5'0952—dc22

 2003023048

Printed in the United States of America

1 2 3 4 5 6 7 8 / 11 10 09 08 07 06 05 04

CONTRIBUTING ARTISTS:

Denise Akemi: 18–19, 26–29, 42–47, 72–75, 84, 92–101
Craig Babiar: 6
Svetlana Chmakova: 1, 8, 20–25, 70–71, 76–83, 102–109
Lee Duhig (color): 131–143
Bob Fillie (color): 8, 36, 60, 70, 84, 110, 126
Christopher Hart: 4, 48–59, 126–143, 131–143 (color)
Hiromi Hasegawa: 30–35, 60–69, 85–91
Atsuko Ishida: 15, 17, 36–41
Jin Song Kim: 110–125
Sam Lotfi: 9–14, 16

Color by Brimstone

VISIT US AT
www.artstudiollc.com

CONTENTS

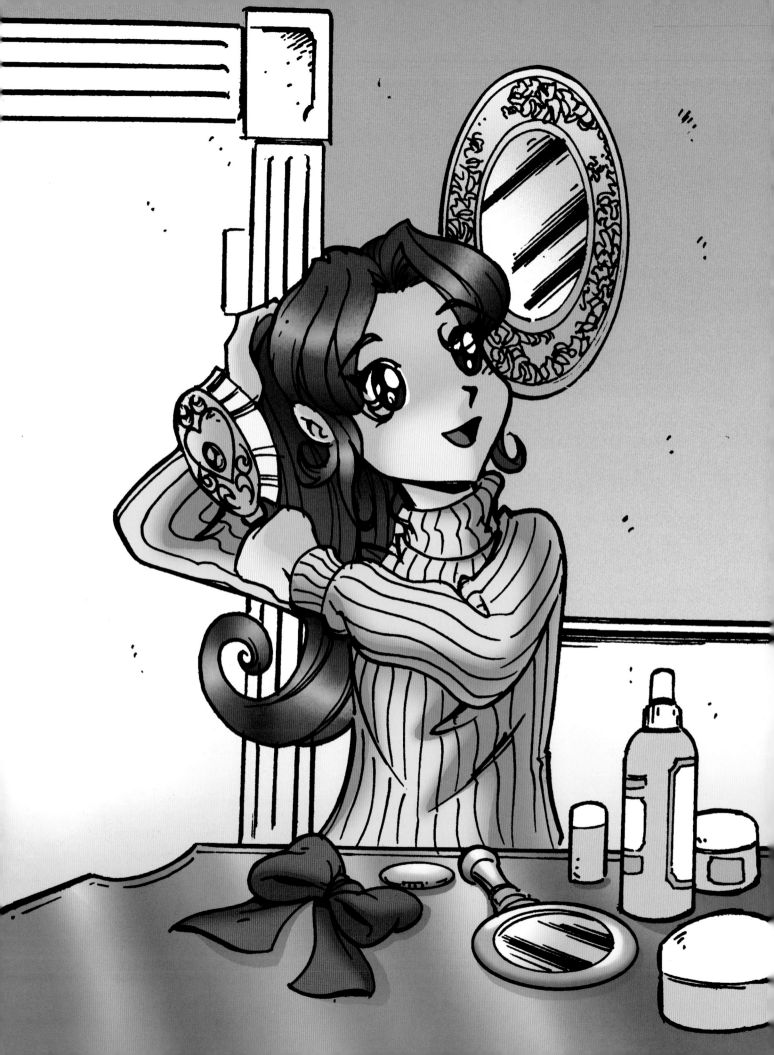

INTRODUCTION

Shoujo is perhaps the best-loved, most recognizable manga style in the world. Famous for the huge brilliant eyes of its characters, shoujo is one of the few comics categories that appeals as much to girls as it does to boys. The faces of the characters are young, sweet, and charming—enchanting, some would even say. The clothes and hairstyles are full of beauty and grace. And while many other styles of manga focus on battles and fight scenes, the shoujo genre concentrates on relationships and adventure. To be sure, there are exciting action scenes in shoujo, especially in the popular Magical Girl subgenre, but even with that, the characters are drawn as real people with real problems that teenagers relate to.

This book is a complete and thorough guide to drawing the world of shoujo manga. It is my intention that you are not only exposed to the rich variety of characters and subgenres that make up shoujo, but that you develop real skill in drawing manga as a result of reading this book. That's why you'll find more step-by-step instruction here than in most other books on manga. Drawing lessons are broken down into steps and principles that aspiring artists can follow with ease. You'll gain insights into drawing and improve as a result.

Shoujo is a huge category, and it consists of many popular subgenres and character types—all illustrated here in abundance—including: Magical Girl , bishies (the boy teen idols of manga), furry characters and mascots, period dramas, school-age dramas, and even the super cute chibis! There are also sections on the amazing eyes of shoujo characters, poses, expressions, costume design, use of shadows, foreshortening, and how to use speech balloons. Rounding things out is a dazzling section on computer coloring that covers all the principles for creating, scanning, and coloring your manga works.

If you love shoujo, and you like to draw, you can't miss by picking up this book. The keys to drawing the most famous manga genre are now at your fingertips. Let's get started!

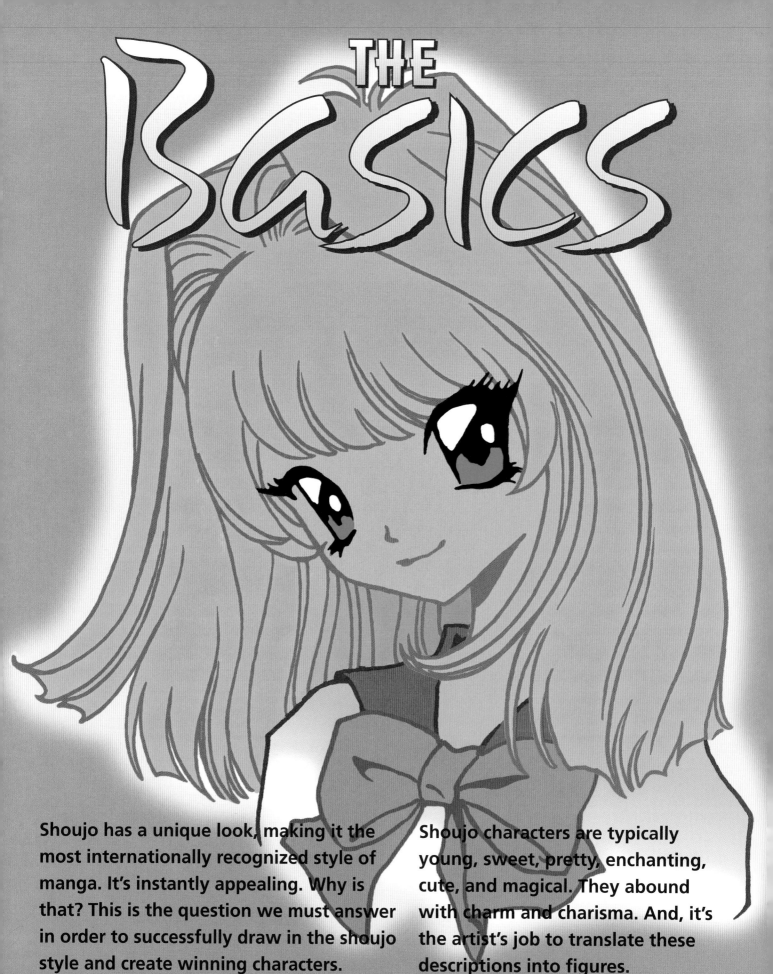

THE BASICS

Shoujo has a unique look, making it the most internationally recognized style of manga. It's instantly appealing. Why is that? This is the question we must answer in order to successfully draw in the shoujo style and create winning characters.

Shoujo characters are typically young, sweet, pretty, enchanting, cute, and magical. They abound with charm and charisma. And, it's the artist's job to translate these descriptions into figures.

Shoujo characters have a youthful, charming look. Start with a young head shape; both young and cute characters have large foreheads and small jaws. Make sure that the eyes are BIG. Big shiny eyes are the trademark of all shoujo characters. By contrast, the nose and mouth should be small and subtle.

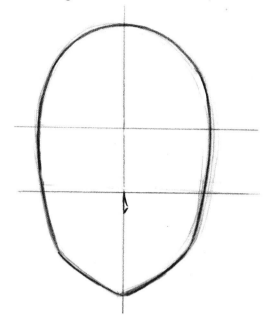

Start with an oval head shape. Place a vertical guideline marking the center of the face. Sketch in one horizontal guideline on which to place the eyes (the lower line above) and another on which to place the eyebrows (the upper line above). This is what artists do to keep the features even. Place the eye guideline low on the face (below the halfway point).

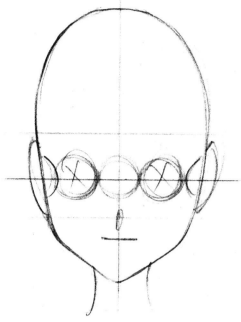

Add another horizontal guideline underneath the other two—just above where the jaw begins to narrow toward the chin—to indicate the nose placement. Sketch in the ears, which stretch from the eyebrow guideline down to the nose guideline. Pencil in the eyes. Normally, the head is 5 eye widths wide, but since the eyes of shoujo characters are so large, the head is only 4 eye widths apart here. Note that there's 1 full eye width between the eyes and 1/2 an eye width on the outer side of each eye.

Erase any unneeded eye guides, and add the eyelids. By sloping the ends of the eyelids down at a sharper angle (toward the earlobes) and adding a few thick eyelashes (see the next page), the eyes become feminine.

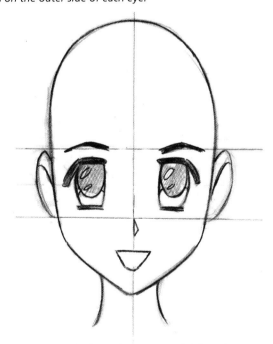

Add the eyebrows, which are thinner on a girl than they are on a boy (see page 13). Sketch in multiple eye shines—at least 2, and often 3 or more. The more shines you use, the wetter and brighter the eyes will appear, which helps convey health, youth, and innocence.

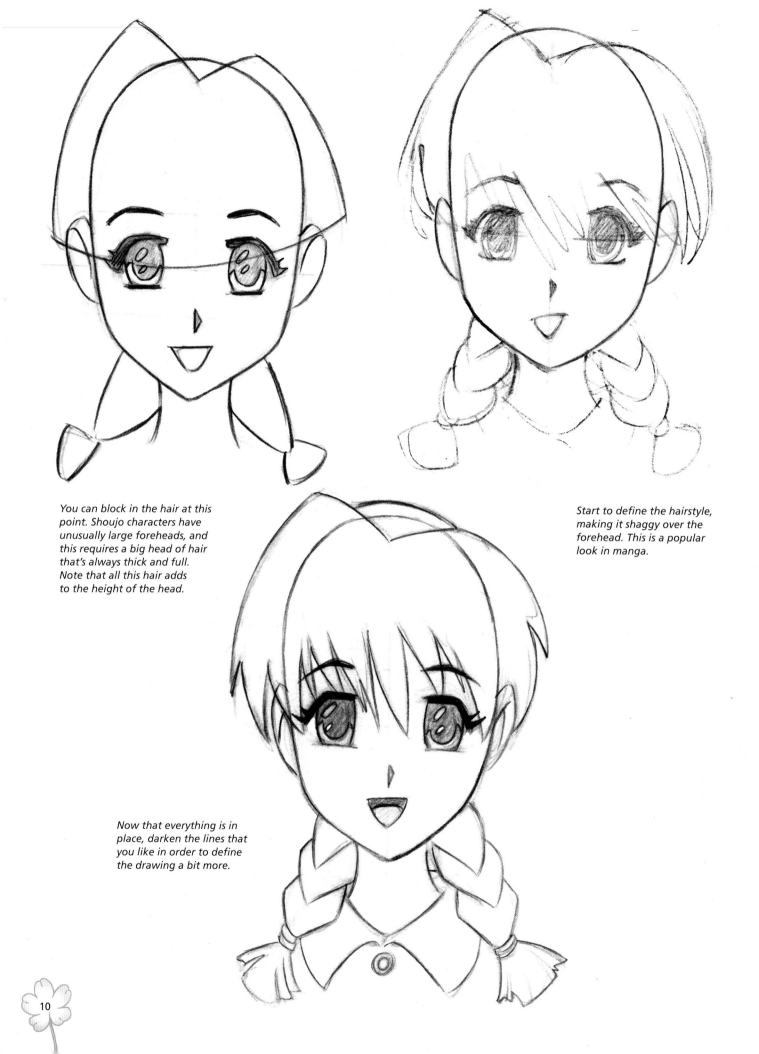

You can block in the hair at this point. Shoujo characters have unusually large foreheads, and this requires a big head of hair that's always thick and full. Note that all this hair adds to the height of the head.

Start to define the hairstyle, making it shaggy over the forehead. This is a popular look in manga.

Now that everything is in place, darken the lines that you like in order to define the drawing a bit more.

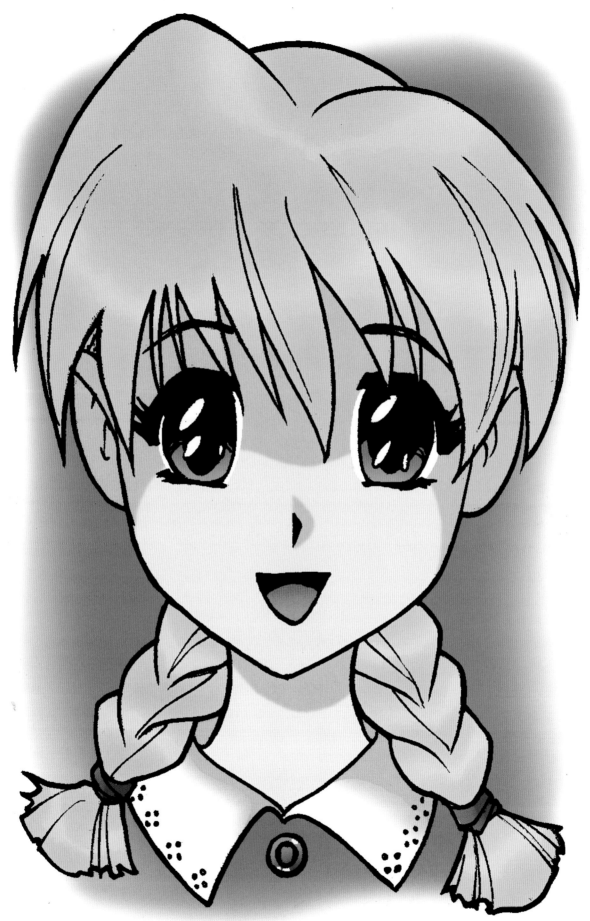

To create a finished look, go over your original drawing in marker, and then erase the pencil lines. Or, you can trace the image (usually on a light box), drawing only the lines you want to keep and omitting the guidelines.

11

Shoujo Boy's Head

In the early stages of the drawing (before adding details to the features), it's hard to tell if the character is a boy or a girl.

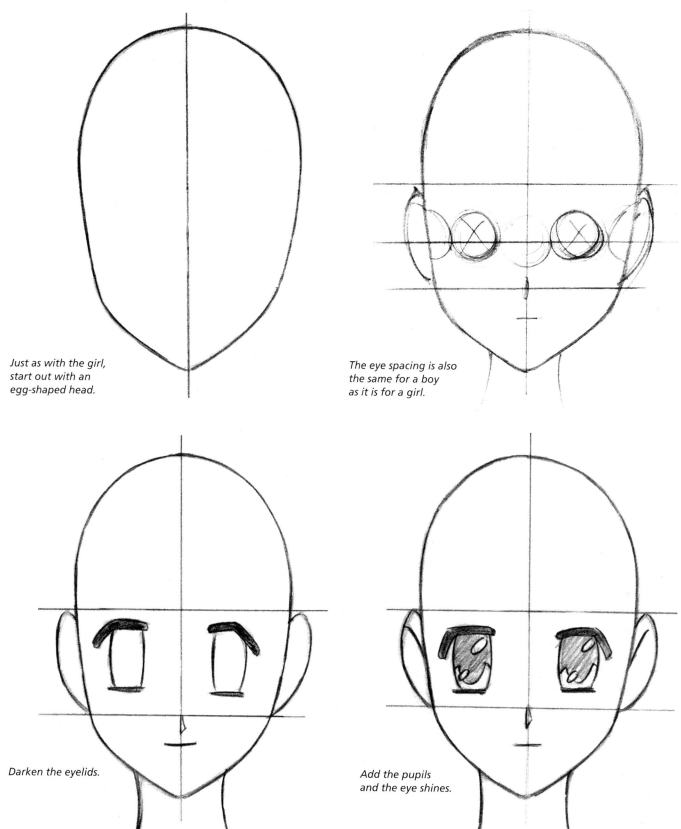

Just as with the girl, start out with an egg-shaped head.

The eye spacing is also the same for a boy as it is for a girl.

Darken the eyelids.

Add the pupils and the eye shines.

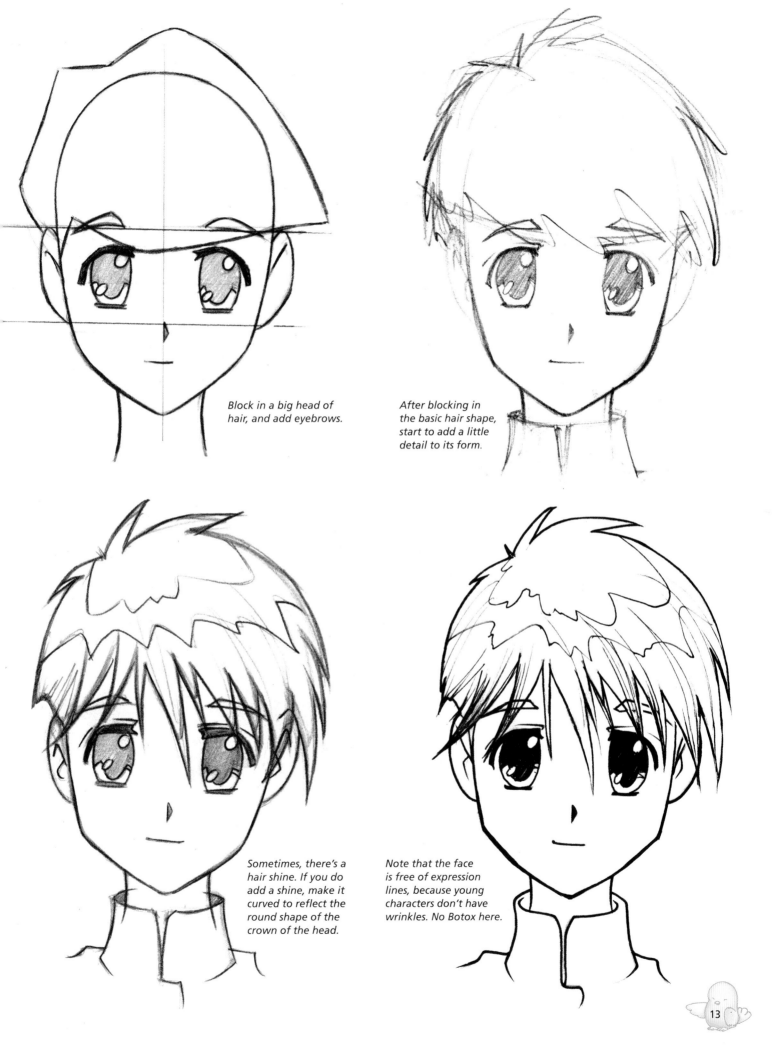

Block in a big head of hair, and add eyebrows.

After blocking in the basic hair shape, start to add a little detail to its form.

Sometimes, there's a hair shine. If you do add a shine, make it curved to reflect the round shape of the crown of the head.

Note that the face is free of expression lines, because young characters don't have wrinkles. No Botox here.

Other Head Angles: Girl

3/4 VIEW

The 3/4 view is a flattering angle. It's a bit more challenging to draw because the two sides of the face aren't mirror images of each other as they are in the front view.

On the far side of the face, the forehead gently curves in, and the cheek gently protrudes out. The far eye is always smaller than the near eye, due to the principles of perspective (which state that things that are farther away from us appear smaller). And, the tip of the nose no longer appears in the middle of the face but is placed closer to the protruding cheek.

With all that hair, it's easy for an artist to get confused when drawing a girl in a 3/4 view. That's why it's important to sketch in a vertical center line to divide the face vertically.

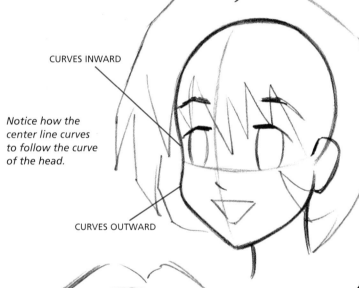

CURVES INWARD

Notice how the center line curves to follow the curve of the head.

CURVES OUTWARD

Also notice that the part in her hair is really just a continuation of that line. The rest of the hair just flops breezily over her forehead and around her face.

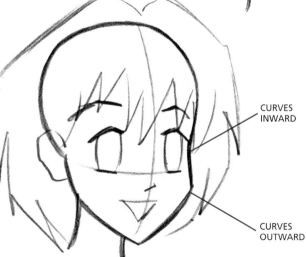

CURVES INWARD

CURVES OUTWARD

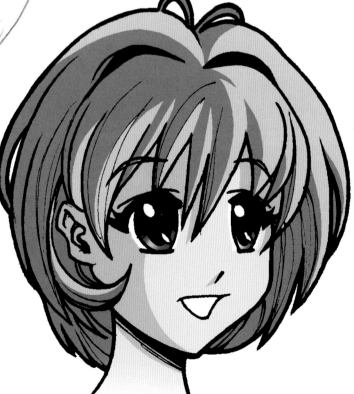

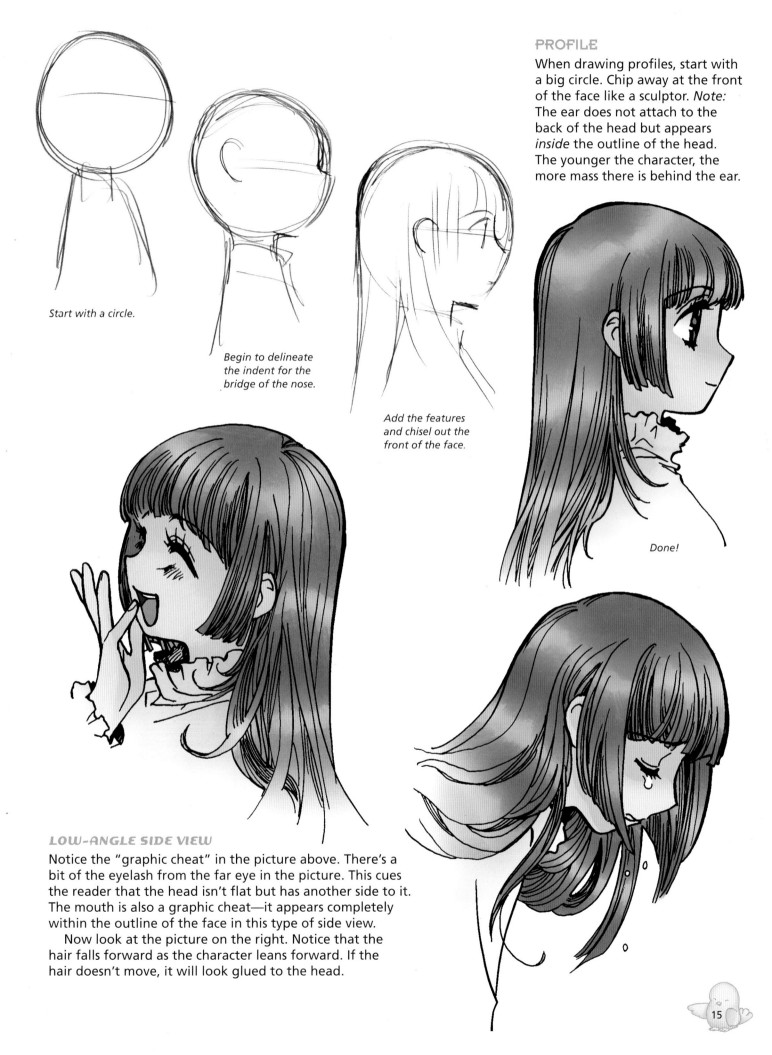

Start with a circle.

Begin to delineate the indent for the bridge of the nose.

Add the features and chisel out the front of the face.

PROFILE

When drawing profiles, start with a big circle. Chip away at the front of the face like a sculptor. *Note:* The ear does not attach to the back of the head but appears *inside* the outline of the head. The younger the character, the more mass there is behind the ear.

Done!

LOW-ANGLE SIDE VIEW

Notice the "graphic cheat" in the picture above. There's a bit of the eyelash from the far eye in the picture. This cues the reader that the head isn't flat but has another side to it. The mouth is also a graphic cheat—it appears completely within the outline of the face in this type of side view.

 Now look at the picture on the right. Notice that the hair falls forward as the character leans forward. If the hair doesn't move, it will look glued to the head.

Other Head Angles: Boy

Notice how the center line (the vertical guideline) aids in the placement of the nose. Also, putting the protruding cheek very low on the face creates a young-looking character.

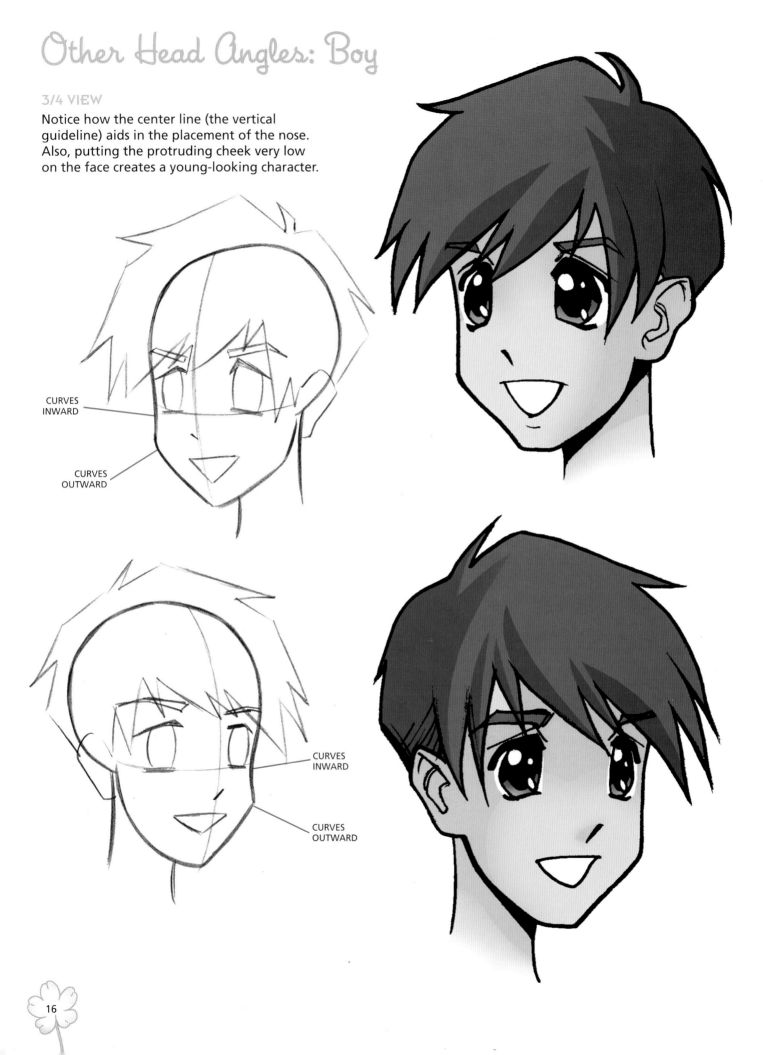

CURVES INWARD

CURVES OUTWARD

CURVES INWARD

CURVES OUTWARD

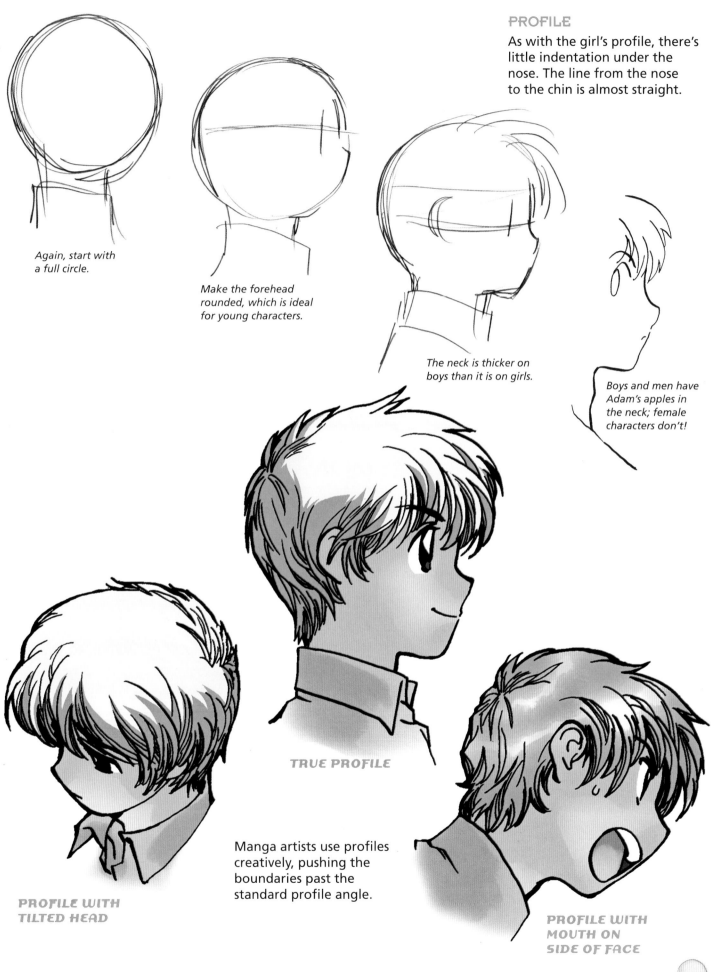

Again, start with a full circle.

Make the forehead rounded, which is ideal for young characters.

The neck is thicker on boys than it is on girls.

PROFILE

As with the girl's profile, there's little indentation under the nose. The line from the nose to the chin is almost straight.

Boys and men have Adam's apples in the neck; female characters don't!

TRUE PROFILE

PROFILE WITH TILTED HEAD

Manga artists use profiles creatively, pushing the boundaries past the standard profile angle.

PROFILE WITH MOUTH ON SIDE OF FACE

17

Expressions

Shoujo expressions are usually subtle, unless—and this is a big unless—it's a big emotion; then, you can go wild. But otherwise, it's more in keeping with the flavor of the genre to go with breezier, underplayed emotions. Simplicity of expression will help you keep the faces innocent and sweet looking, rather than distorting them with a lot of facial dynamics.

SURPRISED

THOUGHTFUL

Note how the hairstyle reflects the emotion of the pose. This is true of all the drawings here.

ANGRY

HAPPY

PLEASED

18

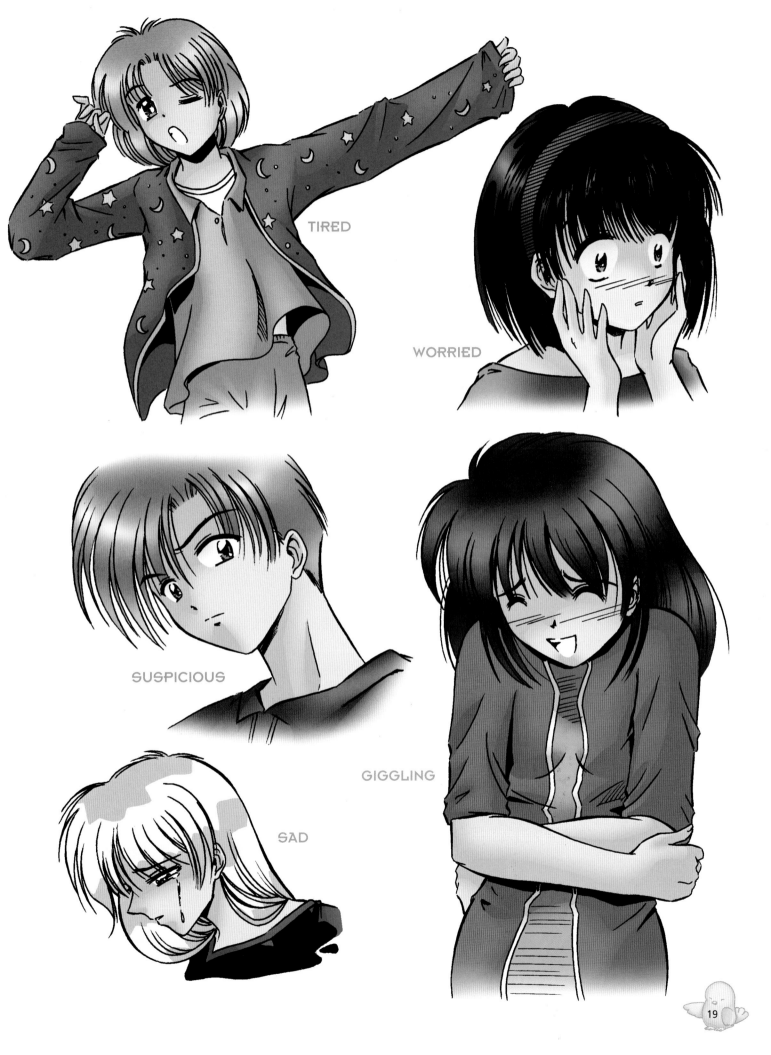

TIRED

WORRIED

SUSPICIOUS

GIGGLING

SAD

Hairstyles

Second only to the eyes in their impact on the reader are the elaborate and extravagant hairstyles of shoujo. The hair is a key feature of the character's design, not something to be added—without much thought —after the fact.

Whether the character is male or female, the hair must be abundant. It must display a conscious style (pigtail, ponytail, braid, bob, long, short, and so on) and must also be full of body. Although not as long or quite as full as girls' hairstyles, boys' hairstyles are, nonetheless, still an impressive display.

There's no such thing as one shoujo hairstyle. There are simply too many character types and too many looks. Nonetheless, there are some basic styles that appear with regularity in shoujo.

FEMALE HEAD CONSTRUCTION WITHOUT HAIR . . .

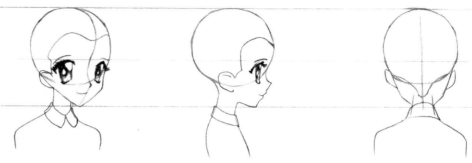

. . . AND WITH HAIR

Notice how much more space the head takes up once you add the hair! Make the hair big!

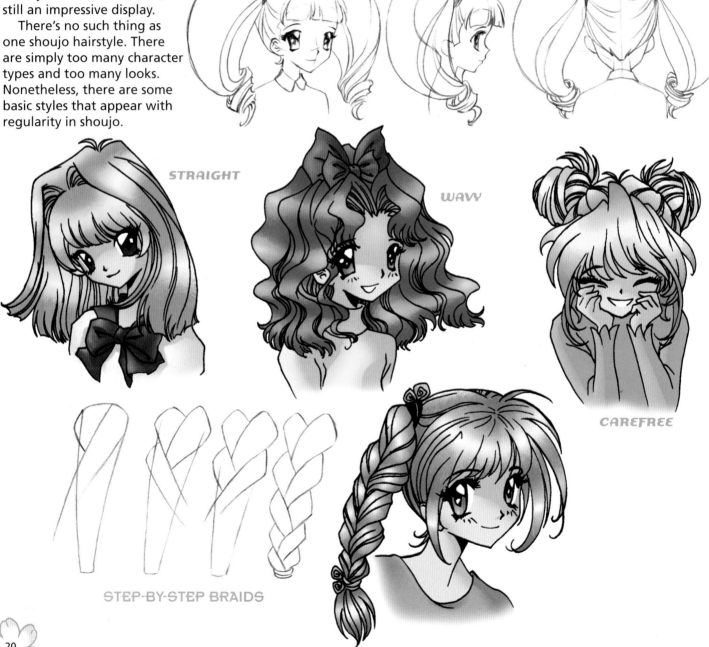

STRAIGHT

WAVY

CAREFREE

STEP-BY-STEP BRAIDS

20

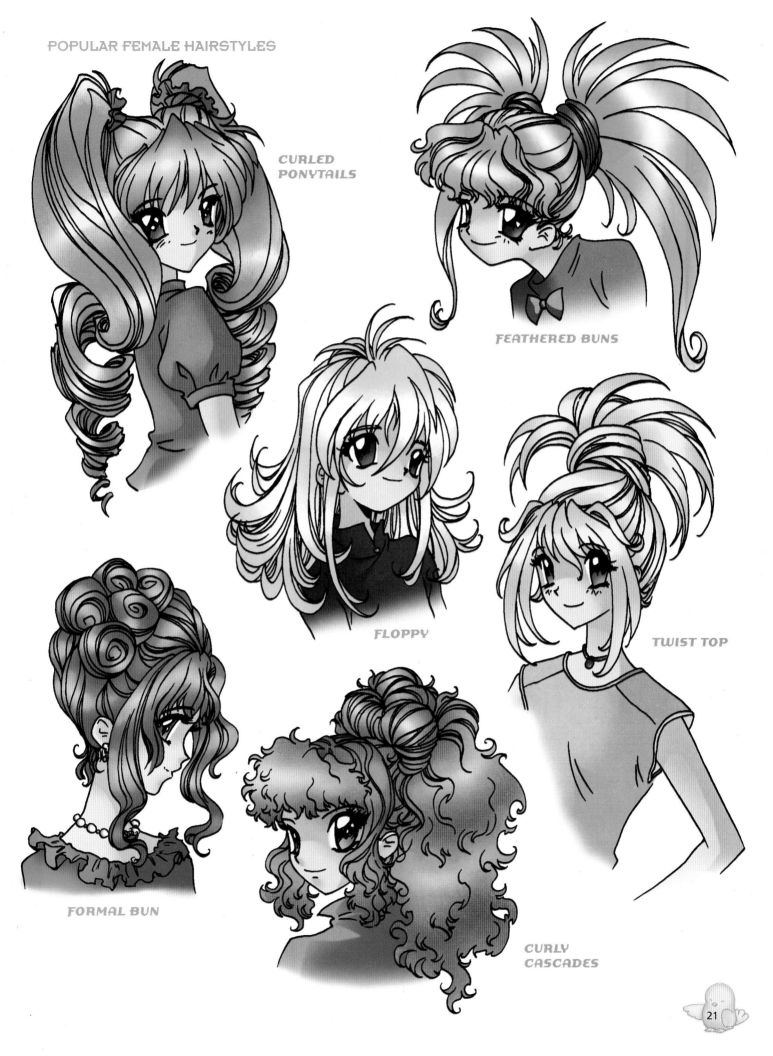

POPULAR FEMALE HAIRSTYLES

CURLED PONYTAILS

FEATHERED BUNS

FLOPPY

TWIST TOP

FORMAL BUN

CURLY CASCADES

MALE HEAD CONSTRUCTION WITHOUT HAIR . . .

. . . AND WITH HAIR

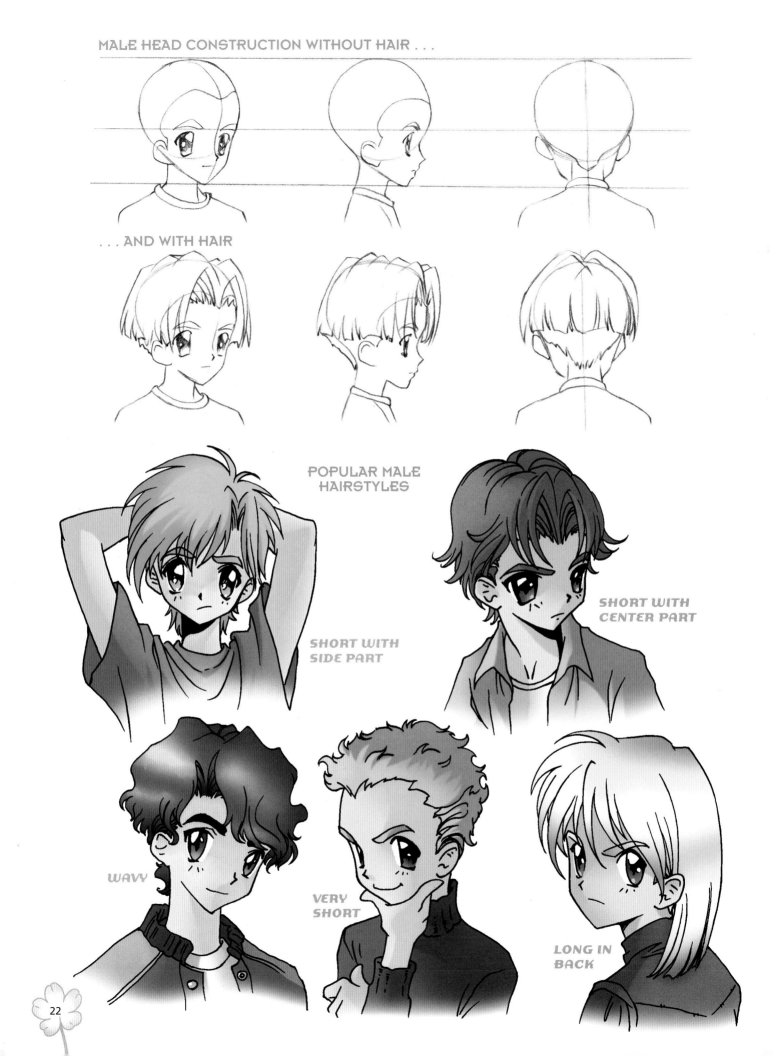

POPULAR MALE HAIRSTYLES

SHORT WITH SIDE PART

SHORT WITH CENTER PART

WAVY

VERY SHORT

LONG IN BACK

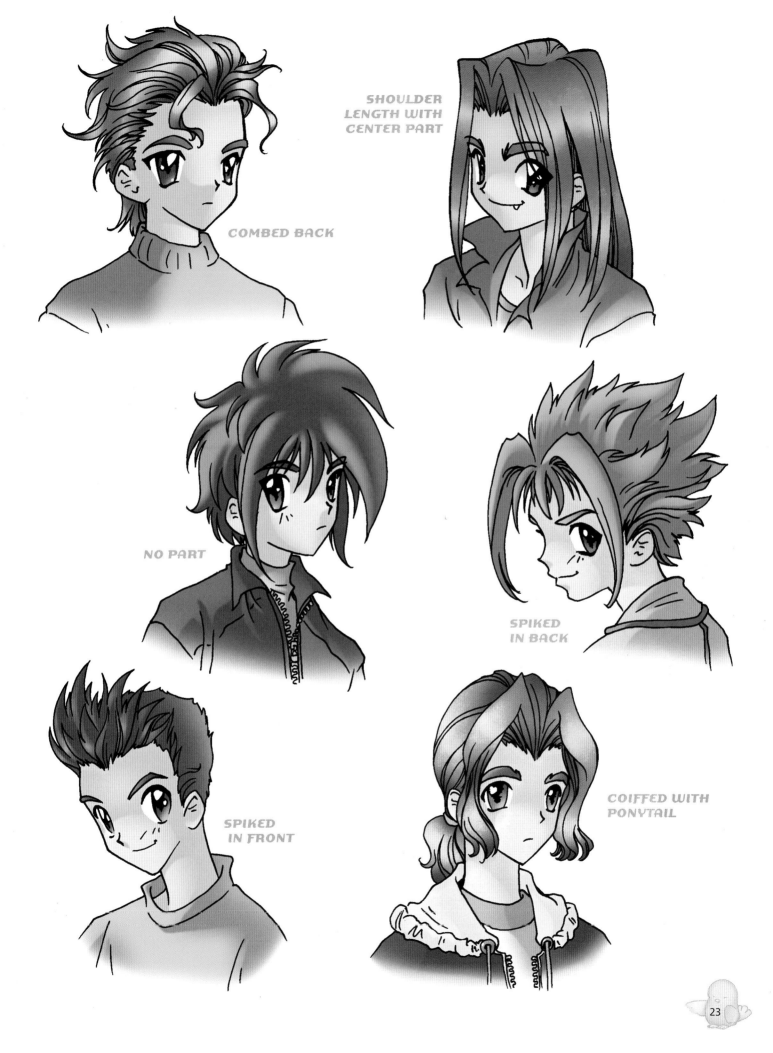

SHOULDER
LENGTH WITH
CENTER PART

COMBED BACK

NO PART

SPIKED
IN BACK

SPIKED
IN FRONT

COIFFED WITH
PONYTAIL

Super-Long Fantasy Hair

This category's the crowd-pleaser of hairstyles. Elegant, super-long fantasy hair creates a dreamy, mystical character. The hair must be long and flowing, drawn with extended rhythmic streaks that articulate many individual strands. The costume must reflect the hairstyle; jeans and a T-shirt wouldn't work in combination with these almost goddesslike manga beauties. The hair can be almost as long as the character herself.

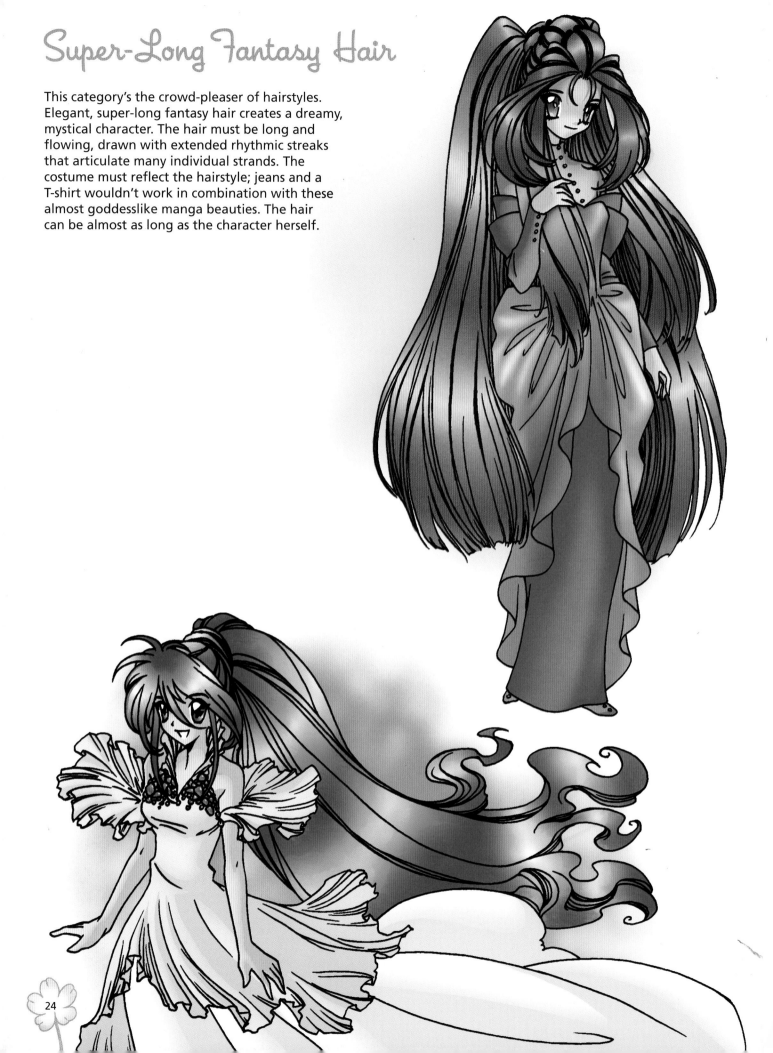

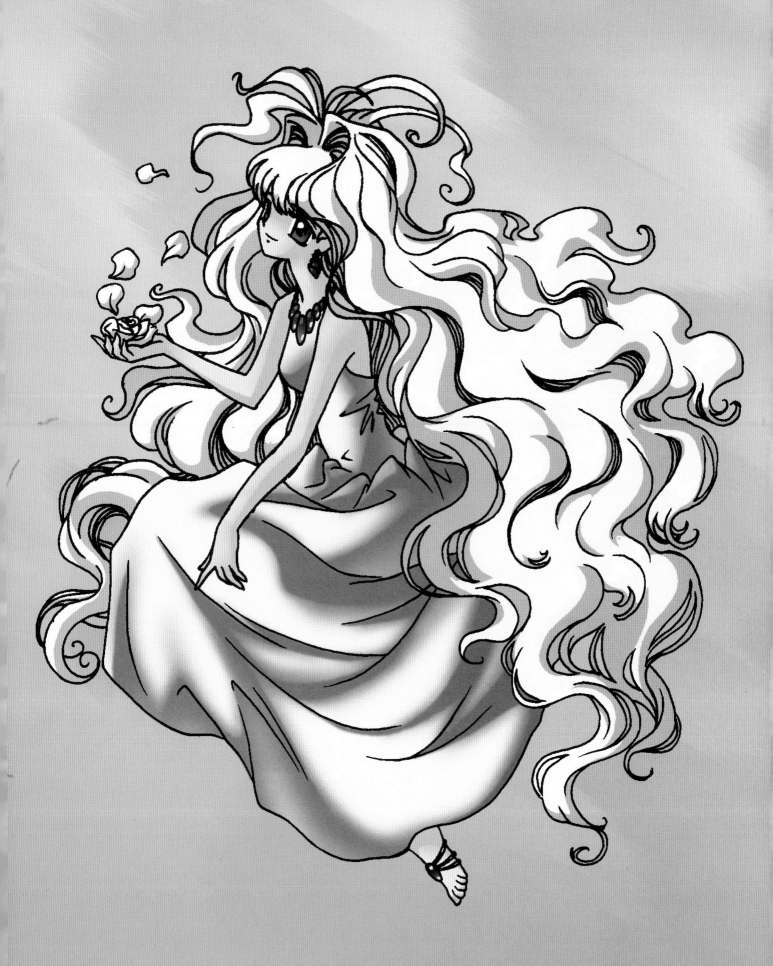

Female Shoujo Body

The female shoujo body should appear soft not bony, skinny, or muscular. It's elongated, with exaggerated length to the legs to create an elegant look, while the torso remains normally proportioned.

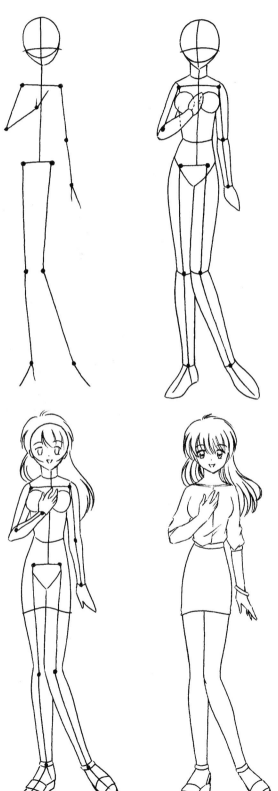

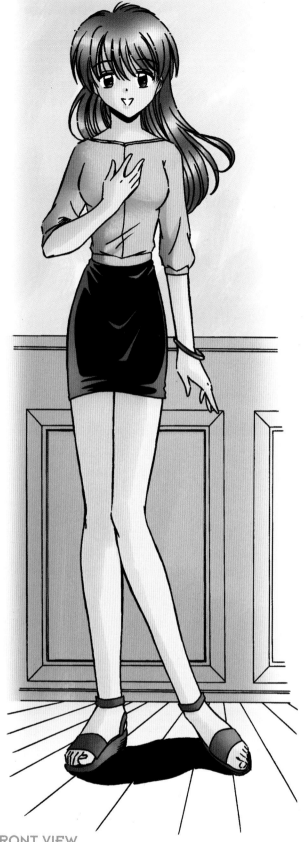

FRONT VIEW

Start with a basic stick figure, but one that shows the width of the body by indicating horizontal lines for the collarbone and the hips. Notice that the hips are narrower than the shoulders on young characters. As a woman matures, her hips usually become wider, becoming the same width as her shoulders. After establishing the stick figure, flesh out the body, and add the clothes last.

SIDE VIEW

Side views are tricky because they tend to flatten out the figure, making it look stiff. To counter this, overlap some parts of the body to indicate depth. For example, here one leg overlaps the other.

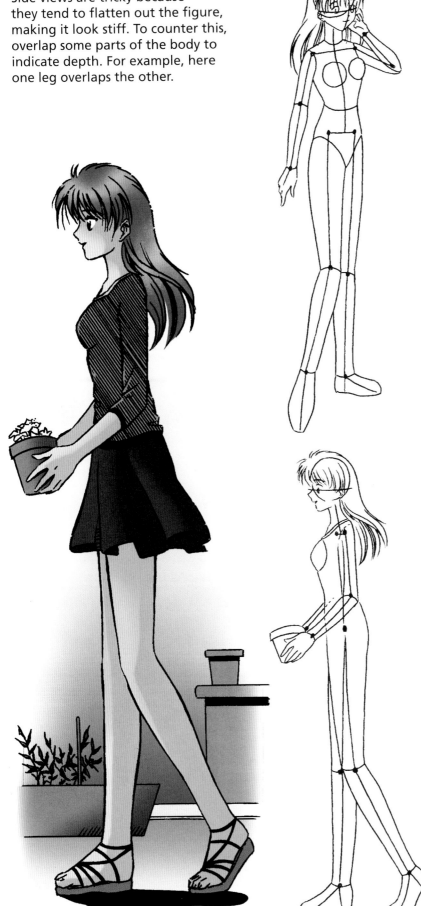

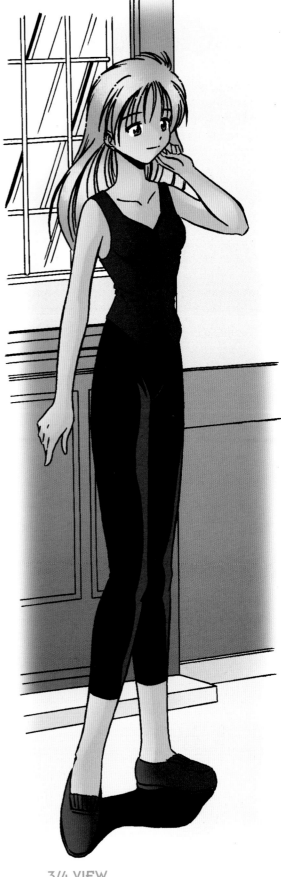

3/4 VIEW

In the 3/4 view, the near side of the body will take up 3/4 of the volume, and the far side of the body, only 1/4. This is a very pleasing angle at which to portray a character.

Male Shoujo Body

The male shoujo body is broader than the female figure, especially at the shoulders, and shows more bony protrusions at the joints. It's not muscular in a weight-lifter sense. Still, there's a self-confidence to most teenage boys that manifests itself in the wide stance, with elbows pointed out and the gaze looking straight ahead.

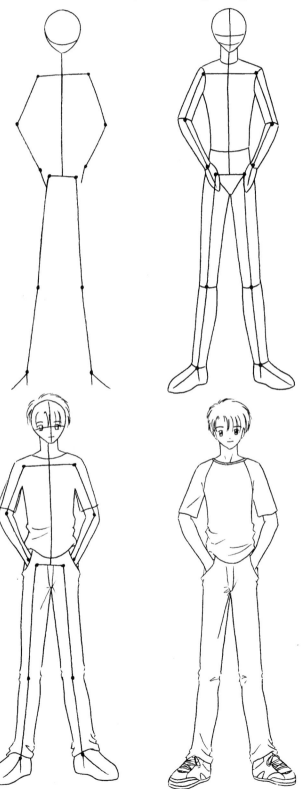

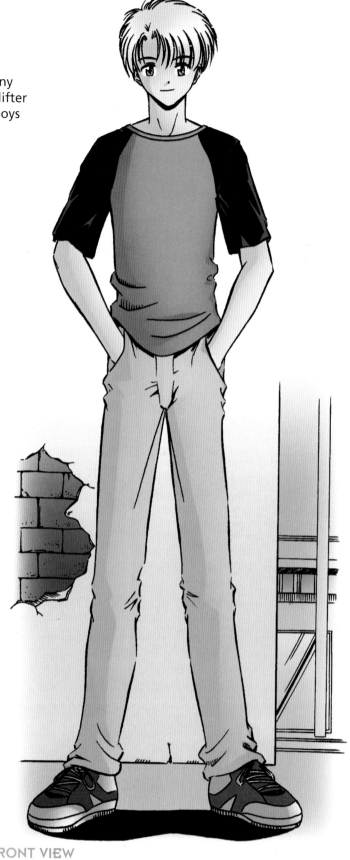

FRONT VIEW

Front views lend themselves to symmetrical poses. Note how the arm position, as well as the leg position, is symmetrical. Drawing an action pose in the front view is difficult, because the body will want to twist and turn for the pose, and in most cases, you'll be forced to use a 3/4 pose.

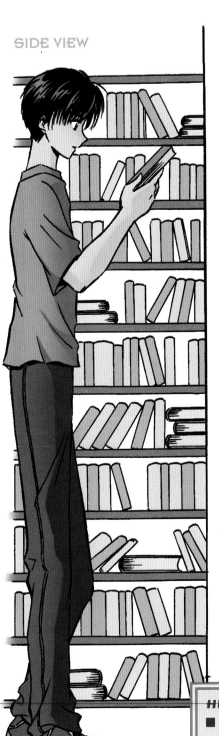

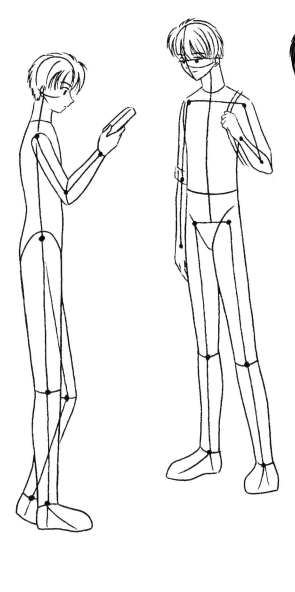

HINTS FOR DRAWING THE MALE BODY

■ Male hips are narrower and square shaped. (Female hips are wider and rounder.)

■ The shoulders are wide.

■ The waist is thicker than the female waist.

■ The male figure is more angular and less curvy than the female figure.

■ The arms show some muscularity.

■ Make sure the neck has length so that the head doesn't look as if it's attached directly to the body.

■ Sketch in the wrinkles of clothing as you create your rough drawing. (This applies to female characters, as well.)

3/4 VIEW

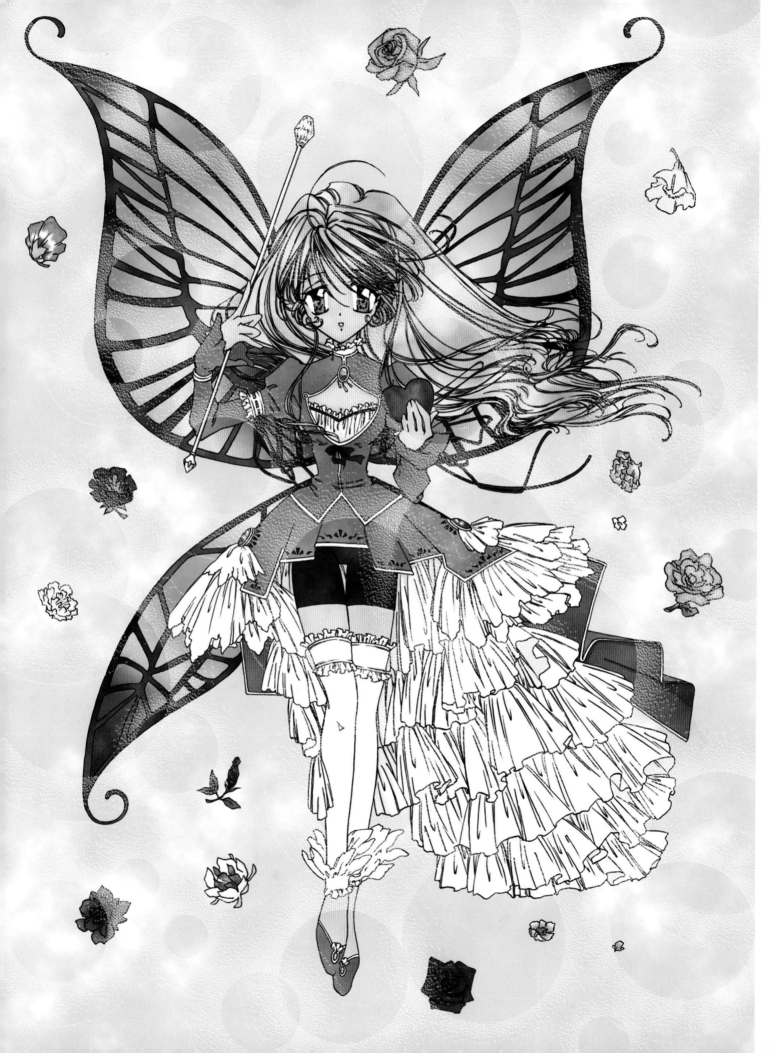

Shoujo artwork is embellished with delicate motifs—graceful decorations that create an overwhelming sense of beauty. These illustrations show how to use graceful enhancements to bring the typical, ornate characters of shoujo to life.

GATHERED LACE TRIM

Draw the rippled edge of gathered lace trim before drawing the folds within it. This edge is a randomly drawn line that flows in and out. Once you've drawn the edge, indicate the fold lines, which create the gathered look of the lace trim.

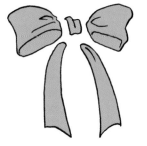

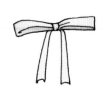

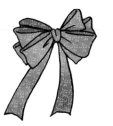

BOWS

Don't let bows look so limp that they lose their form. Although a bow should be flexible and flap in the wind, it should also be a pleasing form and you don't want to abandon that.

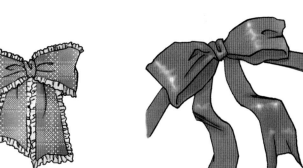

FLOWERS

The most recognizable and often-used flower in shoujo is the rose. It represents love and good feelings. It may be used as an emotional symbol and isn't always used literally as a plant from a garden. When drawing a rose, start in the center and work your way to the outer petals.

These flowers would be used for background decoration.

Flower bouquets are often given as gifts or held in hope by a character.

THE VICTORIAN AGE

It's not uncommon to see the elegant characters of shoujo in period costumes, for stories set in Victorian times for example. It adds to the fantasy element when the kind of formal dress you see in this example would be a part of everyday life.

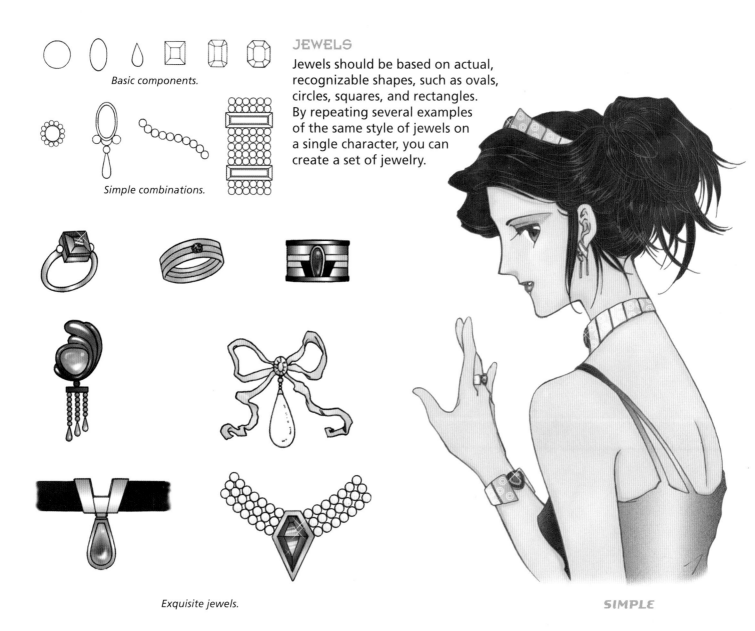

Basic components.

Simple combinations.

JEWELS

Jewels should be based on actual, recognizable shapes, such as ovals, circles, squares, and rectangles. By repeating several examples of the same style of jewels on a single character, you can create a set of jewelry.

Exquisite jewels.

SIMPLE

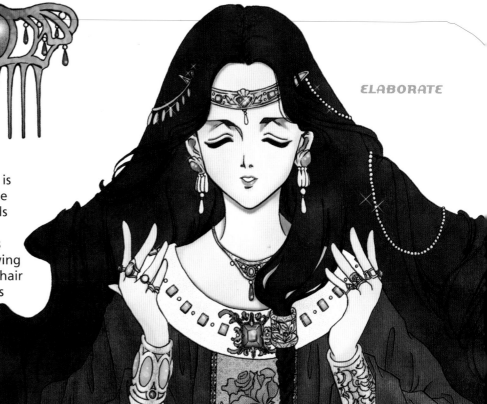

ELABORATE

EARTH GODDESSES

Goddesses are an integral part of the pristine, flowery grace and beauty that is shoujo. A goddess is whatever you make her to be: She can wear the finest jewels and silk, or she can wear handcrafted jewelry and beads. Note that the hair is very detailed. It's important when drawing a graceful character that you draw the hair in a flowing manner. This often involves drawing individual strands of hair, whether the overall feel of the character is simple or elaborate.

Cute Mascots

Mascots are a must in shoujo. Everybody loves them because they're so cute. They usually attach themselves to one character in particular, as a pet might do. Unlike pets, however, they can pop in and out of existence at will. Very cute, those little guys. They're favorites, and readers always look forward to them. They can be silly, loving, loyal, and good-naturedly mischievous. They act as the confidante of one or more of the human characters in a story, helping them in some way, either by giving encouragement or advice (although sometimes only its master can understand what it says).

Cute mascots are often based on real animals, but made to look squeezable and adorable. They generally display the same proportions as baby animals, having long ears, a short nose, a small mouth, a large head in contrast to the body, and being round and plump (or fluffy).

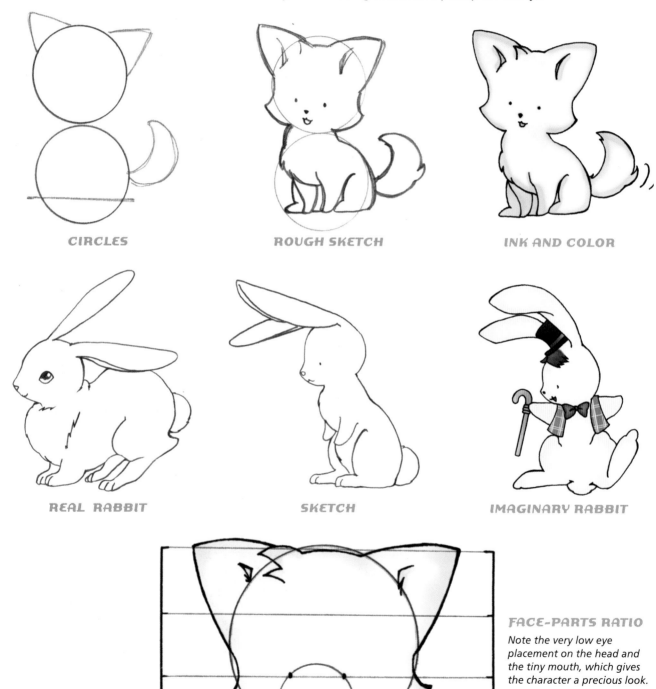

CIRCLES

ROUGH SKETCH

INK AND COLOR

REAL RABBIT

SKETCH

IMAGINARY RABBIT

FACE-PARTS RATIO
Note the very low eye placement on the head and the tiny mouth, which gives the character a precious look.

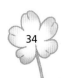

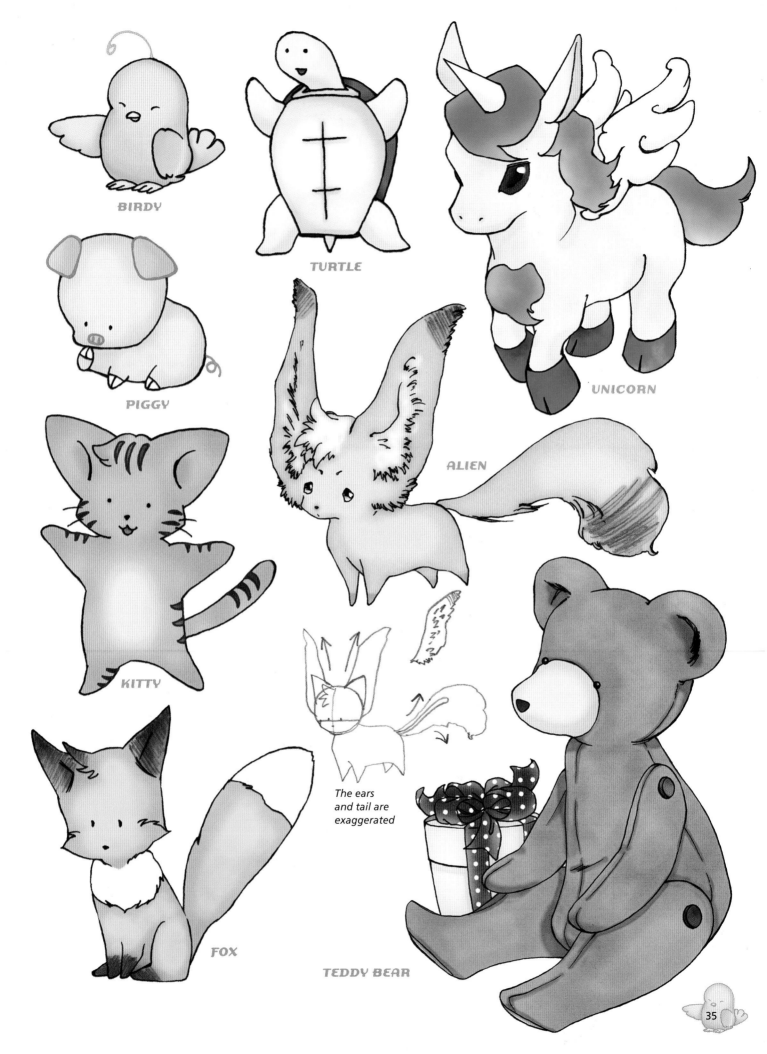

BIRDY

TURTLE

UNICORN

PIGGY

ALIEN

KITTY

The ears
and tail are
exaggerated

FOX

TEDDY BEAR

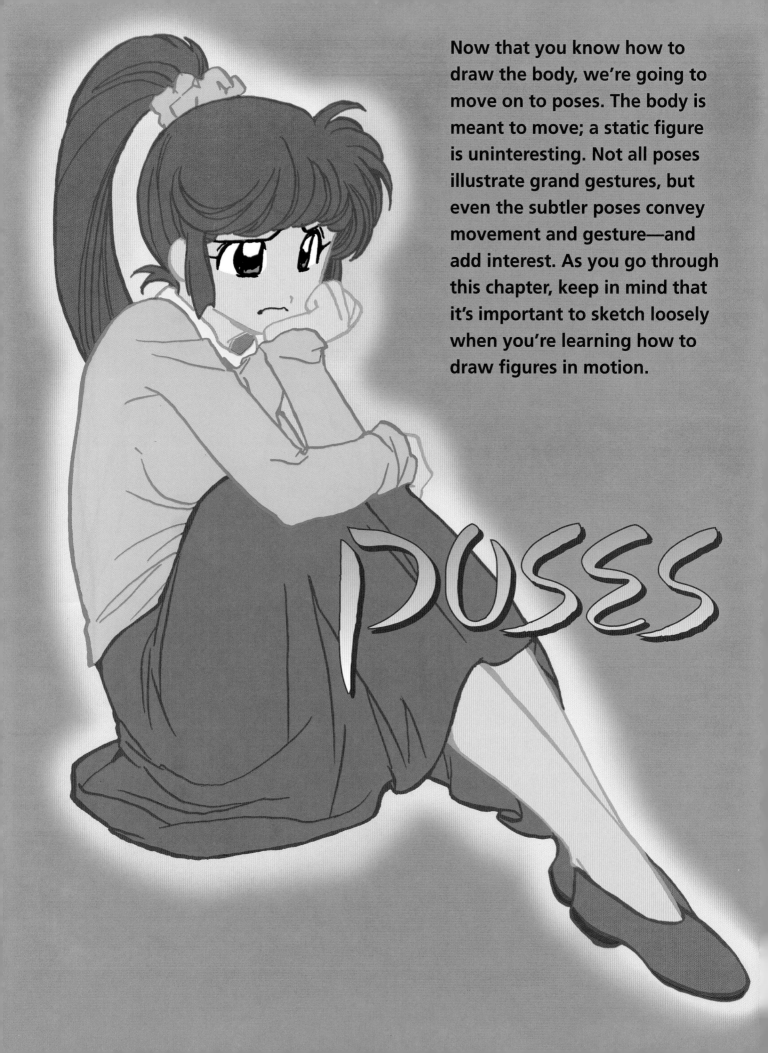

Now that you know how to draw the body, we're going to move on to poses. The body is meant to move; a static figure is uninteresting. Not all poses illustrate grand gestures, but even the subtler poses convey movement and gesture—and add interest. As you go through this chapter, keep in mind that it's important to sketch loosely when you're learning how to draw figures in motion.

Poses

Gesture Poses

When artists draw a character, they often explore a number of poses before deciding on the best one. A common practice is to draw the variations onto a single pose rather than redrawing the pose several different ways. This is called a *gesture pose*. Most beginners don't experiment like this; they're too concerned with avoiding mistakes at all costs, and therefore, they restrict themselves. But professionals know that it's in the freedom of the gesture poses that you find your best drawing.

A good start.

Some experimenting with arm gestures.

Hey, that looks good. Let's follow up on it!

Now that you've settled on a pose, you can work more details into the sketch, including blocking in the eyes.

Also, work some detail into the clothes.

Thumbnail Sketches

Another technique that professional manga artists use for "discovering" a good pose is to make a series of what's known as *thumbnail sketches* or *thumbnails.* These are simple, small, quick sketches, drawn without detail. They are used to show the spirit of the pose rather than drawing technique. They're quick visualizations of ideas and notions that aren't yet fully executed.

Once you decide on the main idea, you can combine the poses to make a new one. Take a look at the progression here.

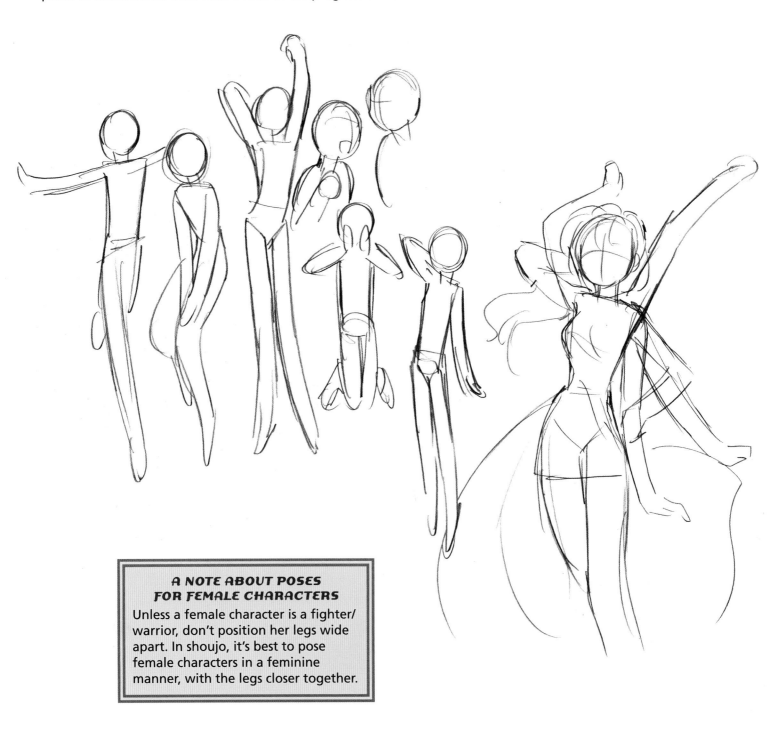

A NOTE ABOUT POSES FOR FEMALE CHARACTERS
Unless a female character is a fighter/warrior, don't position her legs wide apart. In shoujo, it's best to pose female characters in a feminine manner, with the legs closer together.

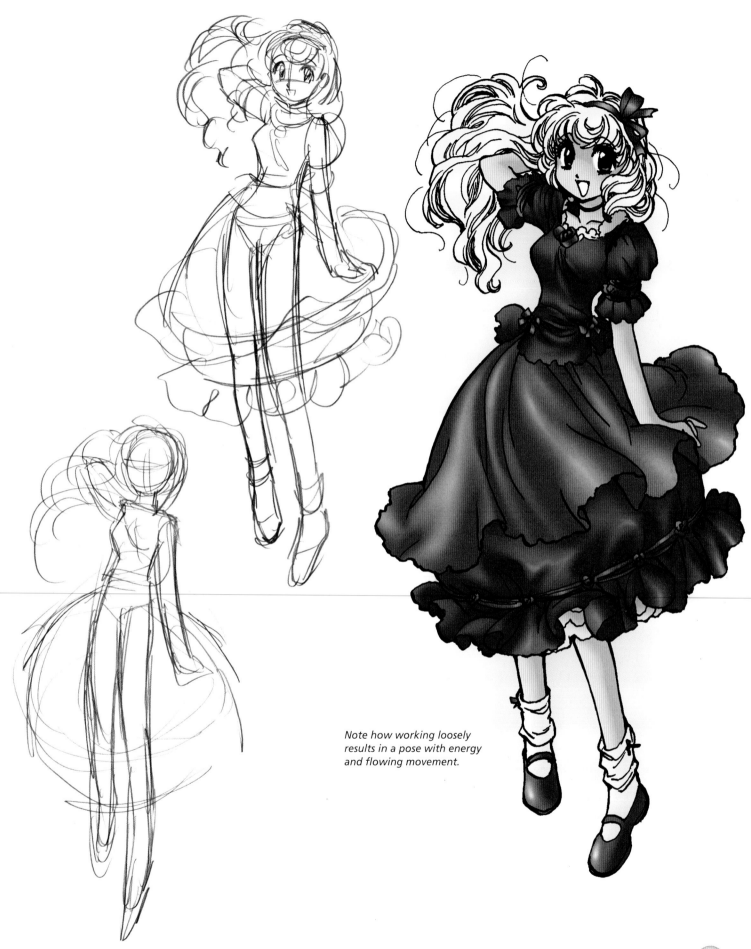

Note how working loosely results in a pose with energy and flowing movement.

Overall Expression

The body reflects a character's state of mind. It shows the character's reaction to a thought or event. If two characters are sitting together, the one who is worried and deep in thought will sit in a different position from the other.

Each drawing here shows how pose, clothes, hair, and facial expression all combine to convey a certain emotion. Note that you can still draw in a sketchy manner. Don't be in a rush to draw precisely; your imagination needs freedom to express itself.

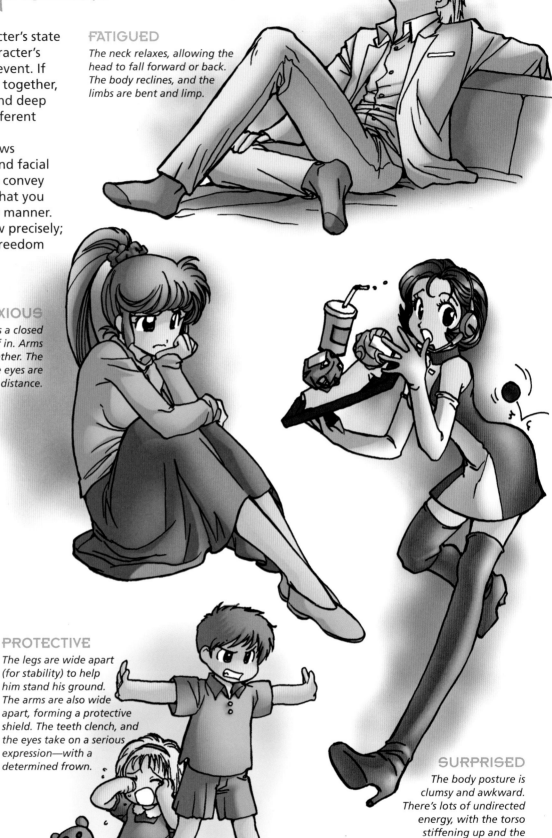

FATIGUED

The neck relaxes, allowing the head to fall forward or back. The body reclines, and the limbs are bent and limp.

PENSIVE OR ANXIOUS

The body adopts a closed posture, fencing itself in. Arms and legs are close together. The mouth is tense, and the eyes are focused off in the distance.

PROTECTIVE

The legs are wide apart (for stability) to help him stand his ground. The arms are also wide apart, forming a protective shield. The teeth clench, and the eyes take on a serious expression—with a determined frown.

SURPRISED

The body posture is clumsy and awkward. There's lots of undirected energy, with the torso stiffening up and the back arching. The eyes and mouth open wide.

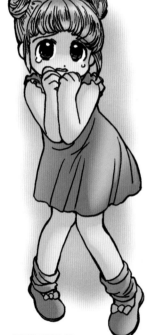

FEARFUL

The knees buckle, and the body goes into a slight crouch. The character bites her nails, the eyes open wide, and tears well up.

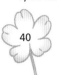

Body Language

Many aspiring manga artists think of expression as something that occurs only in the face. But you can't very well draw a sad expression and not have it reflected in the pose. So, you have to think of expression as a state of mind that affects the entire character—both the face and the body. This is especially true with shoujo characters, who have buoyant personalities. Here are some good examples of facial expressions with their corresponding body language.

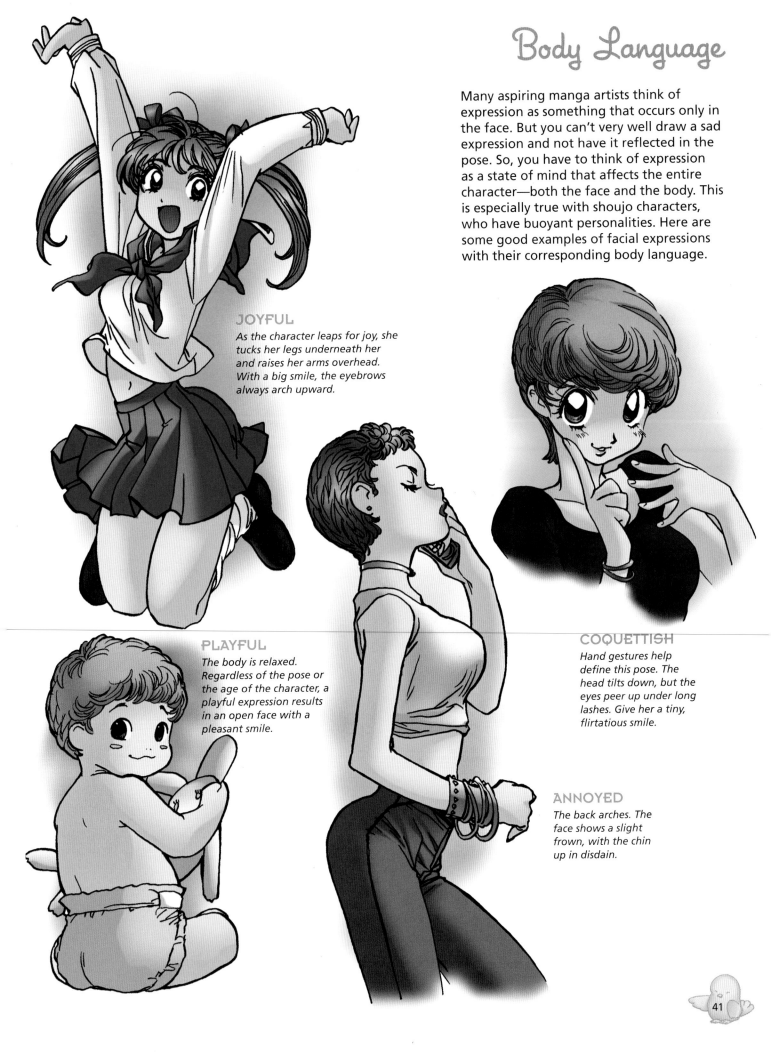

JOYFUL

As the character leaps for joy, she tucks her legs underneath her and raises her arms overhead. With a big smile, the eyebrows always arch upward.

PLAYFUL

The body is relaxed. Regardless of the pose or the age of the character, a playful expression results in an open face with a pleasant smile.

COQUETTISH

Hand gestures help define this pose. The head tilts down, but the eyes peer up under long lashes. Give her a tiny, flirtatious smile.

ANNOYED

The back arches. The face shows a slight frown, with the chin up in disdain.

Drawing Hands

You only get better at drawings hands by drawing hands, which is my way of suggesting that you don't avoid drawing them. There are a tremendous amount of good hand poses in this book for you to practice on. Almost every pose, unless it's a close-up shot, features hands. If you spend as much time copying them as you do copying faces, you'll be good at drawing hands in no time. *Note:* In shoujo, the hands are more delicate than in other genres. The fingers should taper at the tips.

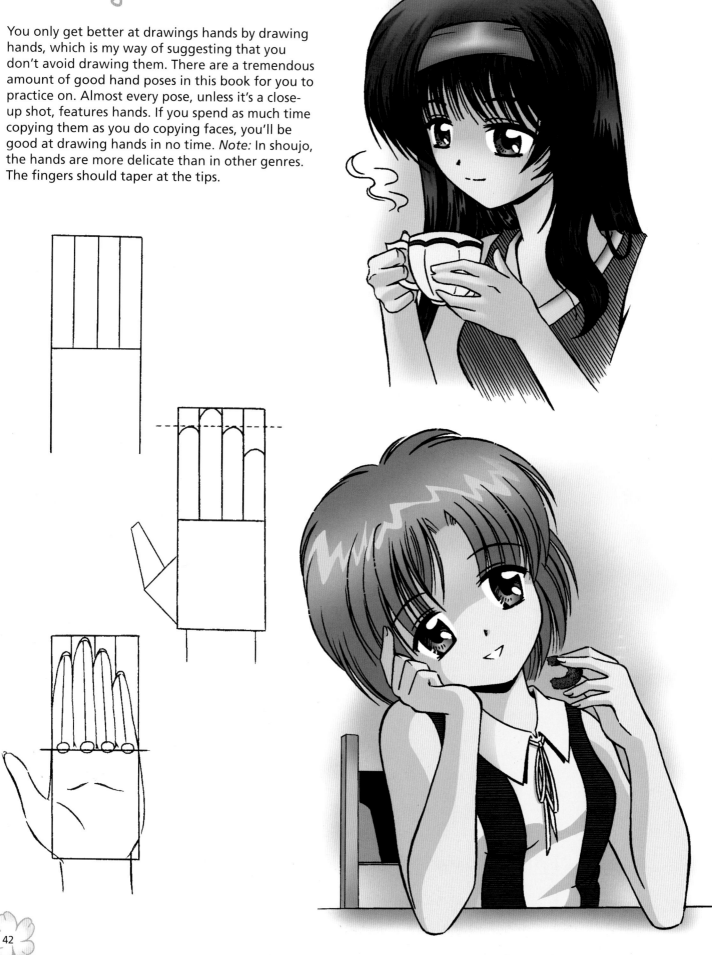

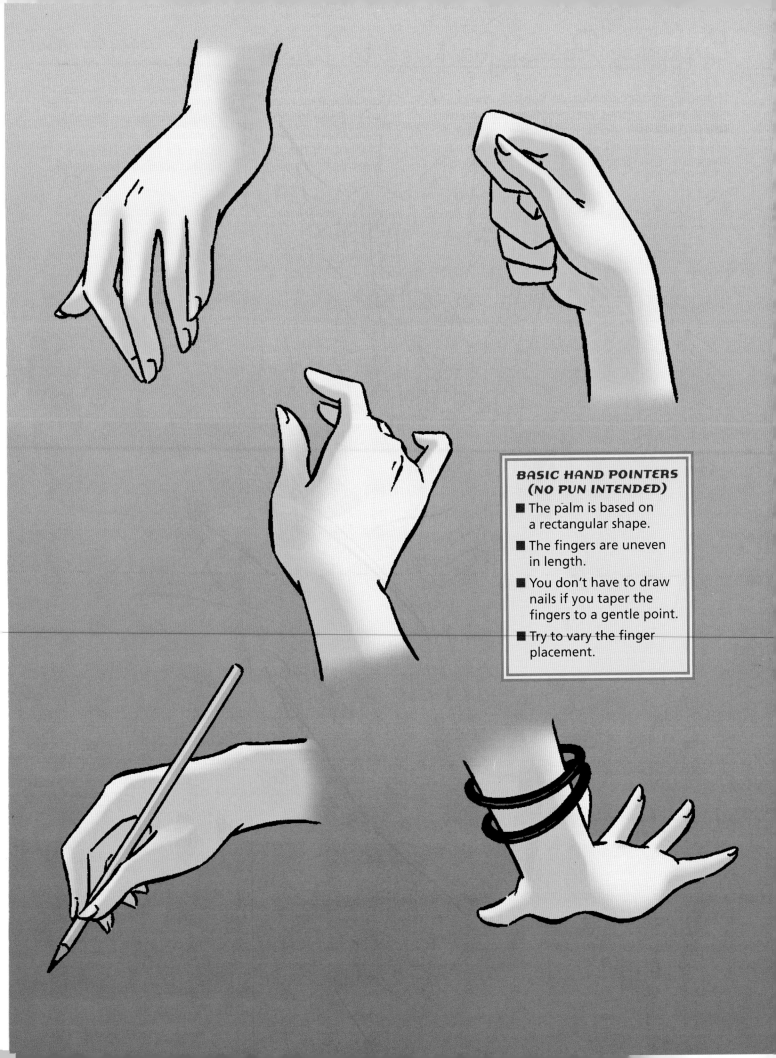

**BASIC HAND POINTERS
(NO PUN INTENDED)**

■ The palm is based on a rectangular shape.

■ The fingers are uneven in length.

■ You don't have to draw nails if you taper the fingers to a gentle point.

■ Try to vary the finger placement.

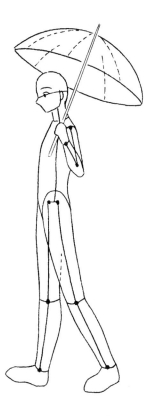

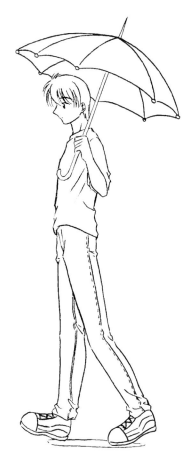

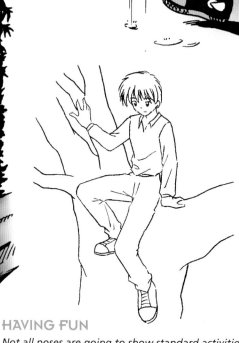

STROLLING

In a casual walk, the body leans slightly backward. The faster the walk, the further forward the body leans.

HAVING FUN

Not all poses are going to show standard activities. If you haven't drawn a pose before, and you have no reference material, you need to ask yourself some questions about the activity represented, in this case tree-climbing. For example, what's the most important thing about tree-climbing? Not falling off, of course! Therefore, the character would use all of his limbs to keep himself in place.

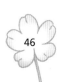

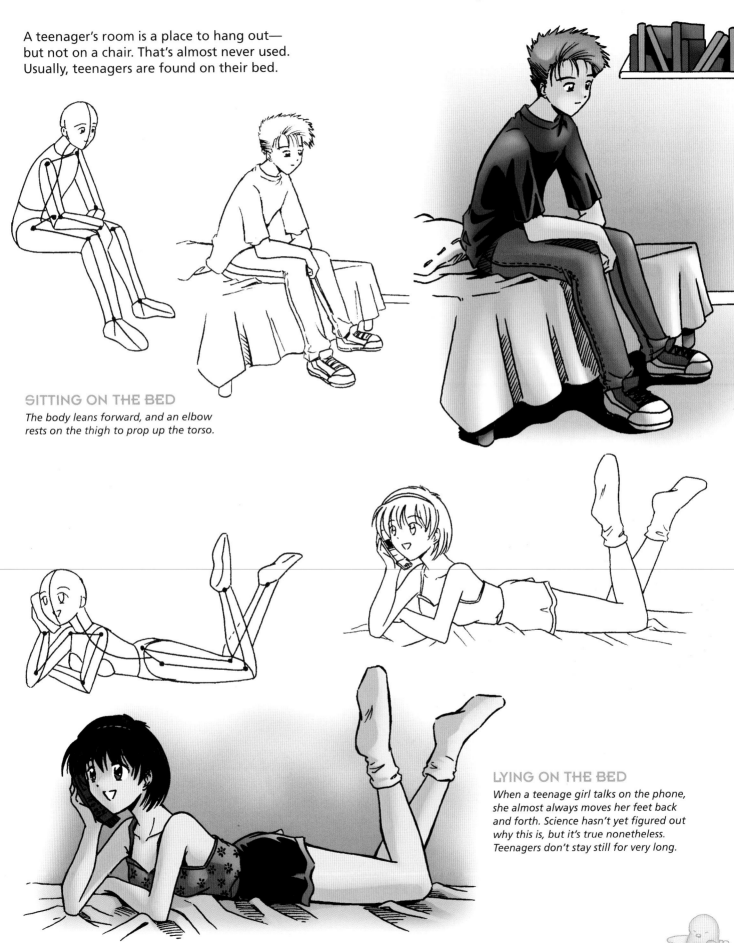

A teenager's room is a place to hang out—but not on a chair. That's almost never used. Usually, teenagers are found on their bed.

SITTING ON THE BED

The body leans forward, and an elbow rests on the thigh to prop up the torso.

LYING ON THE BED

When a teenage girl talks on the phone, she almost always moves her feet back and forth. Science hasn't yet figured out why this is, but it's true nonetheless. Teenagers don't stay still for very long.

47

Foreshortening

Foreshortening is a technique that artists use to create the illusion of depth. Some poses greatly benefit from foreshortening. You've all seen a pose showing a person pointing a finger right at you and in which the hand is drawn bigger than it normally would be to show that it is closer to—and coming toward—you. That's an example of foreshortening. Things that are closer to the viewer should be drawn larger.

There's also another method of showing foreshortening: using overlapped shapes. By overlapping the shapes that make up an object, you create the illusion that the object has depth. It's the way to make two dimensions seem like three, in turn making an object look more realistic and less flat.

This princess' arms appear to come toward the reader. To accomplish this the forearms and hands are drawn slightly larger than they really would be. The forearms are also overlapping the upper arms a bit. This is done by articulating the creases in the elbows, which are the points where the overlap occurs.

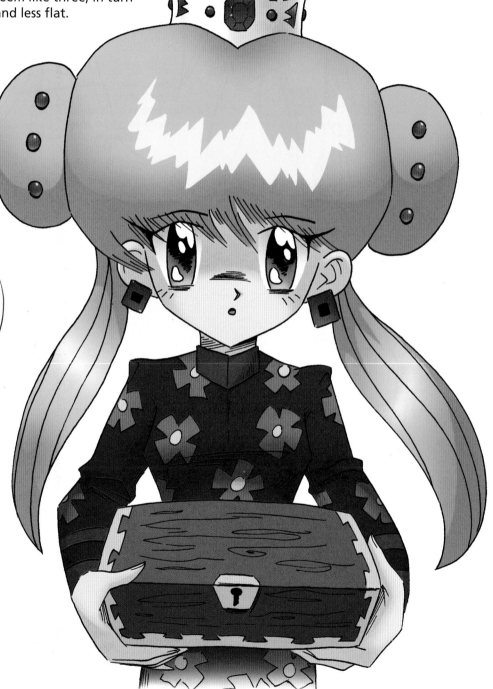

The curved line in the elbows overlaps the upper arms.

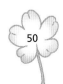

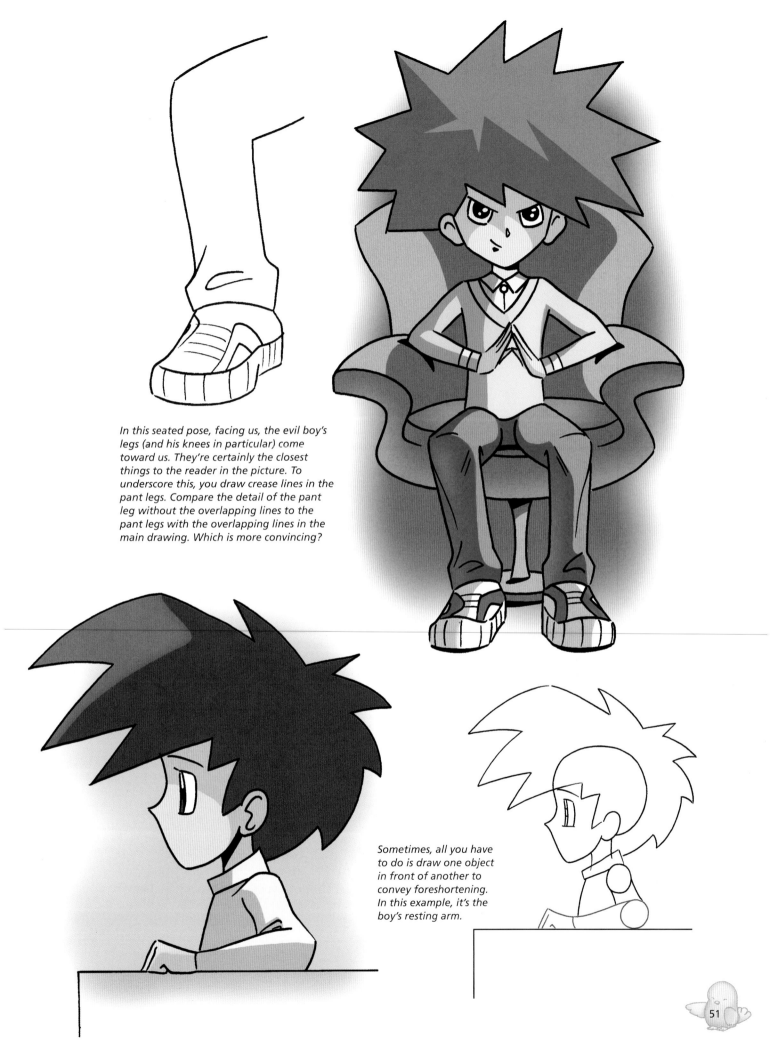

In this seated pose, facing us, the evil boy's legs (and his knees in particular) come toward us. They're certainly the closest things to the reader in the picture. To underscore this, you draw crease lines in the pant legs. Compare the detail of the pant leg without the overlapping lines to the pant legs with the overlapping lines in the main drawing. Which is more convincing?

Sometimes, all you have to do is draw one object in front of another to convey foreshortening. In this example, it's the boy's resting arm.

Total Compression

Sometimes, an object is so severely foreshortened that it completely obscures what's behind it. In this example, one sneaker comes directly at us, masking the leg behind it. In cases like this, the object nearest the reader must be exaggerated even further.

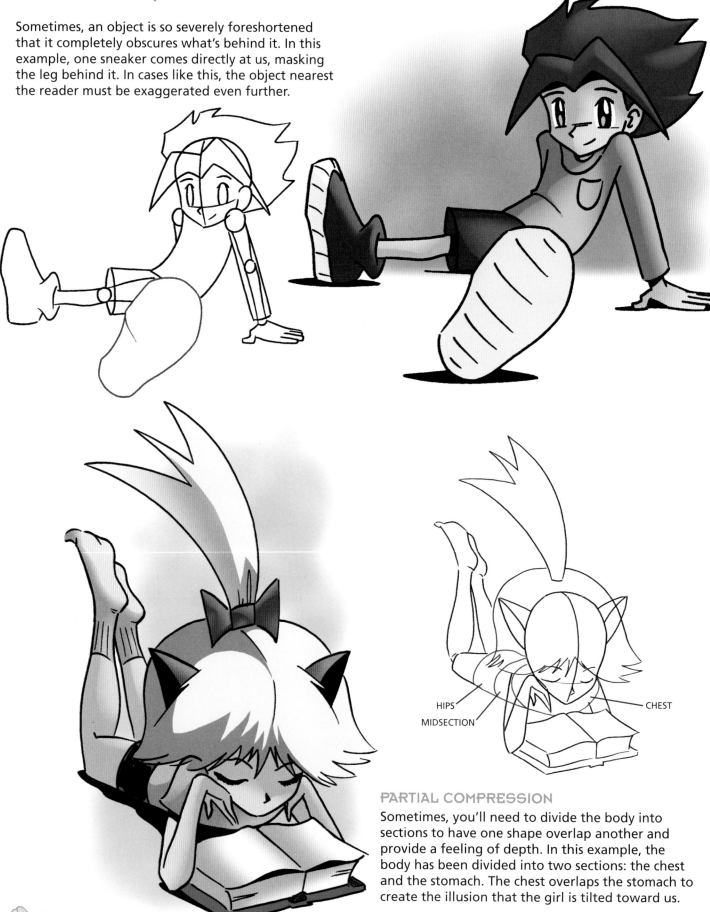

HIPS
MIDSECTION
CHEST

PARTIAL COMPRESSION

Sometimes, you'll need to divide the body into sections to have one shape overlap another and provide a feeling of depth. In this example, the body has been divided into two sections: the chest and the stomach. The chest overlaps the stomach to create the illusion that the girl is tilted toward us.

I'm sure you've used some shading at some point but found that it looked messy. And, you can't help but notice that manga uses lots of effective shading—it's an essential part of the drawing style. So, exactly how do you use shading for manga? Well, I'm exactly gonna show you!

Many Japanese comics are printed only in black and white, and therefore, shadows must be used to give characters a feeling of weight, solidity, roundness, variety, and impact. A character drawn with shadows will have much more of an impact on the reader than one drawn without them. These don't have to be heavily dramatic shadows. (Even small, well-placed shadows help to tie an image together in the same way that punctuation marks tie a sentence together.) Charming shoujo characters aren't made to look grave by the addition of shadows; rather, they end up looking more 3-dimensional and real.

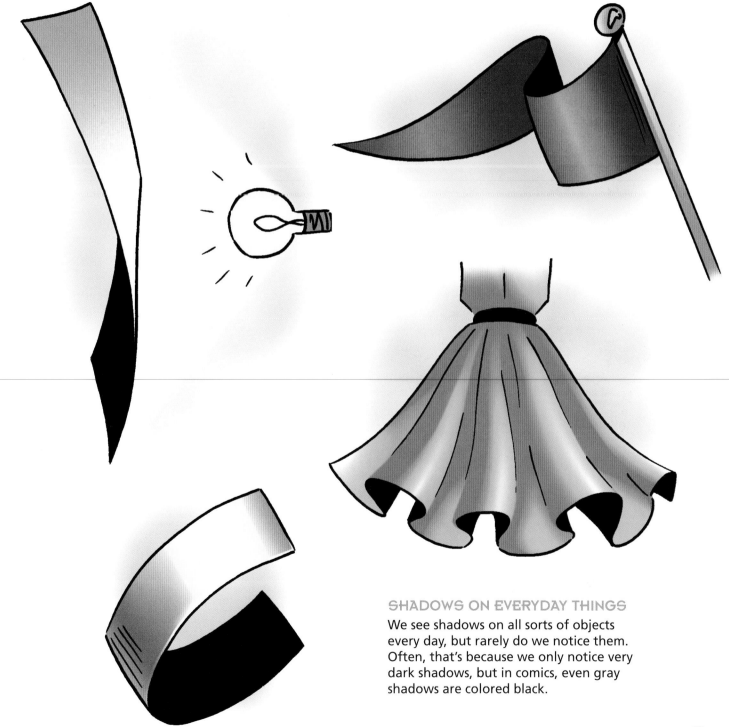

SHADOWS ON EVERYDAY THINGS

We see shadows on all sorts of objects every day, but rarely do we notice them. Often, that's because we only notice very dark shadows, but in comics, even gray shadows are colored black.

SHADOWS ON THE HEAD

When the hair rises up from the head and flops over the forehead, it leaves a shadow underneath it. This may not seem like much, or even worth mentioning, but trust me, it is. In fact, the popular middle-part hairstyle is greatly improved by the addition of shadows. So remember, when drawing a face, you're not done until you fill in the shadows under the hair.

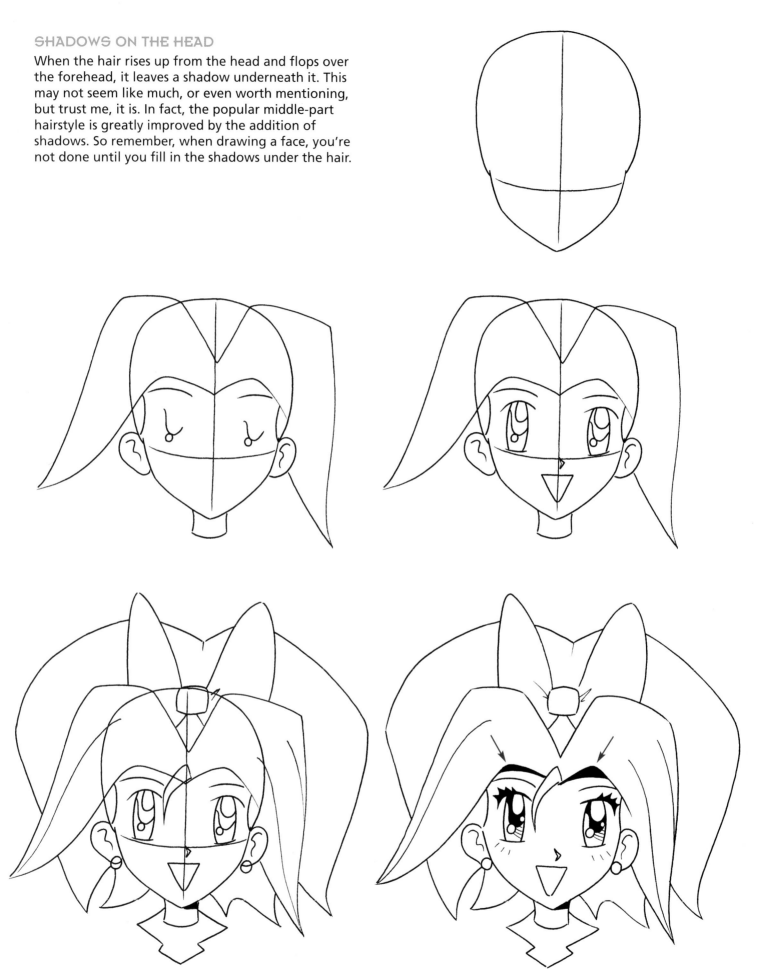

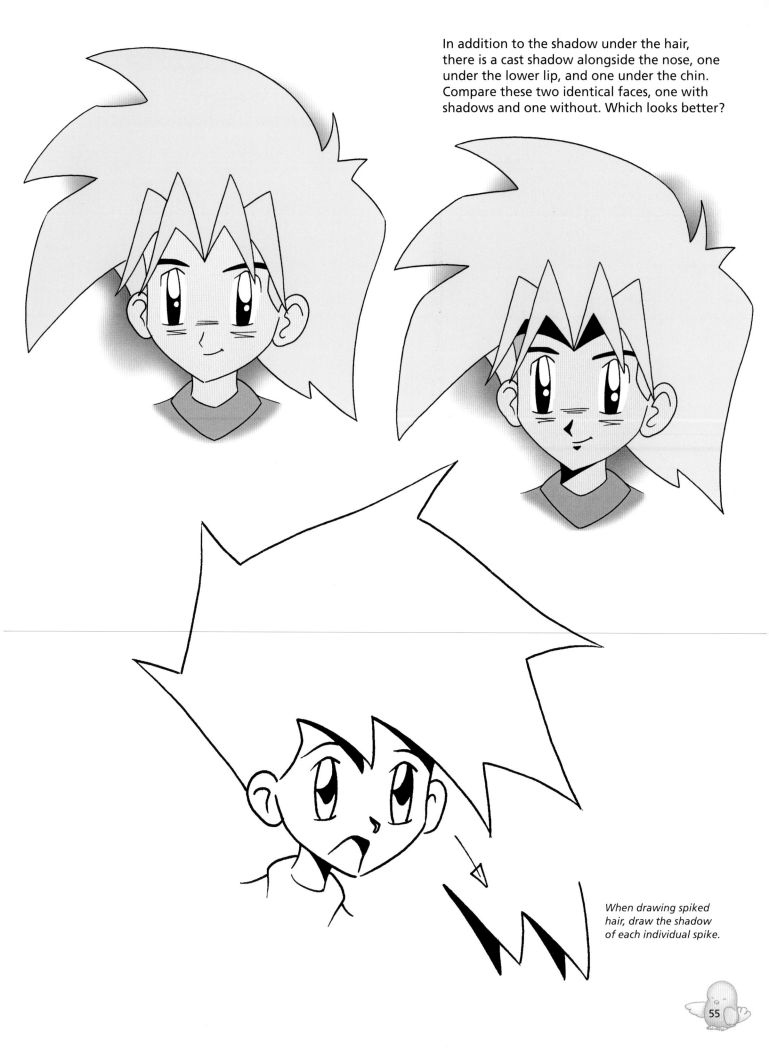

In addition to the shadow under the hair, there is a cast shadow alongside the nose, one under the lower lip, and one under the chin. Compare these two identical faces, one with shadows and one without. Which looks better?

When drawing spiked hair, draw the shadow of each individual spike.

Cast Shadows

In these examples, shadows have been cast from one part of the body onto another part, or from a piece of clothing onto the body. Unless there's another source, one can safely assume that the light is coming from above—in the form of sunlight or indoor lighting. (Other sources might include lighting from below and from the side, both very dramatic lighting conditions that are used with more frequency in western comics.)

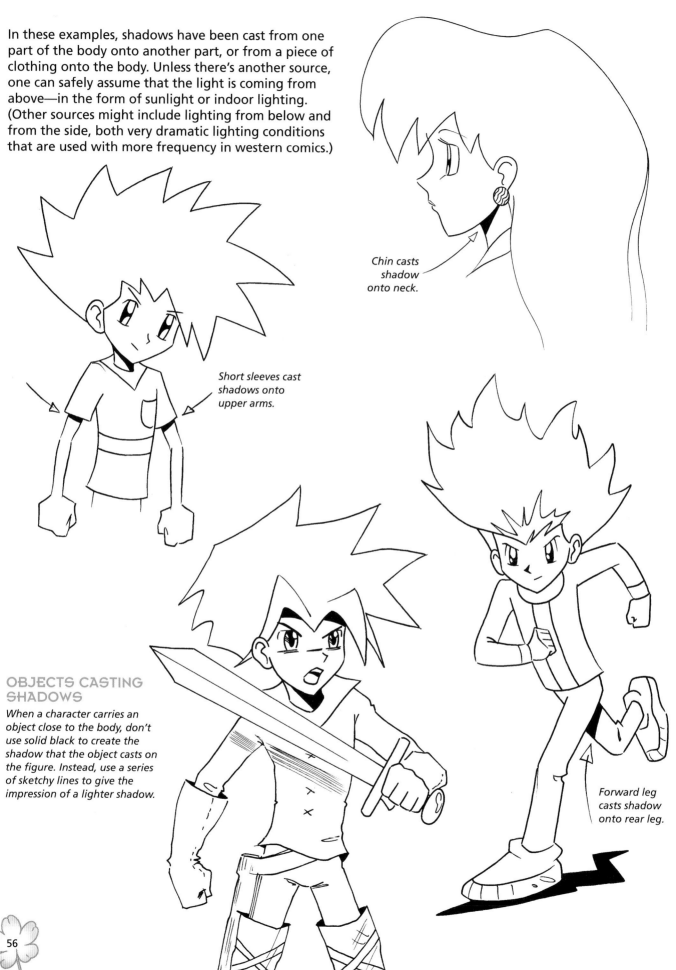

Chin casts shadow onto neck.

Short sleeves cast shadows onto upper arms.

OBJECTS CASTING SHADOWS

When a character carries an object close to the body, don't use solid black to create the shadow that the object casts on the figure. Instead, use a series of sketchy lines to give the impression of a lighter shadow.

Forward leg casts shadow onto rear leg.

Clothing Shadows

Besides articulating layers of clothes, shadows on clothing also help to increase the contrast, making the clothes stand out.

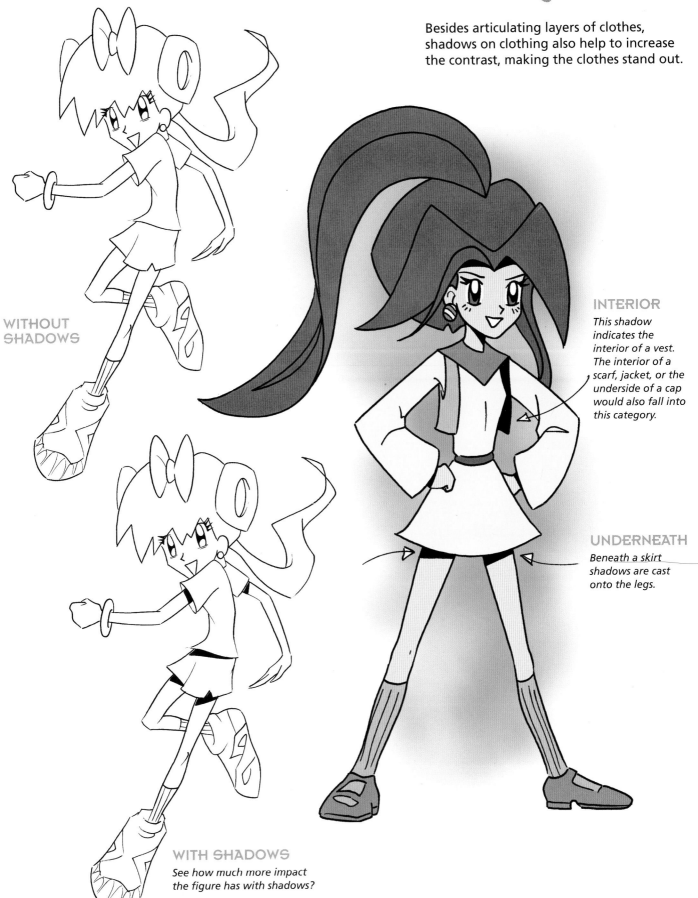

WITHOUT SHADOWS

WITH SHADOWS
See how much more impact the figure has with shadows?

INTERIOR
This shadow indicates the interior of a vest. The interior of a scarf, jacket, or the underside of a cap would also fall into this category.

UNDERNEATH
Beneath a skirt shadows are cast onto the legs.

Shadows on the Ground

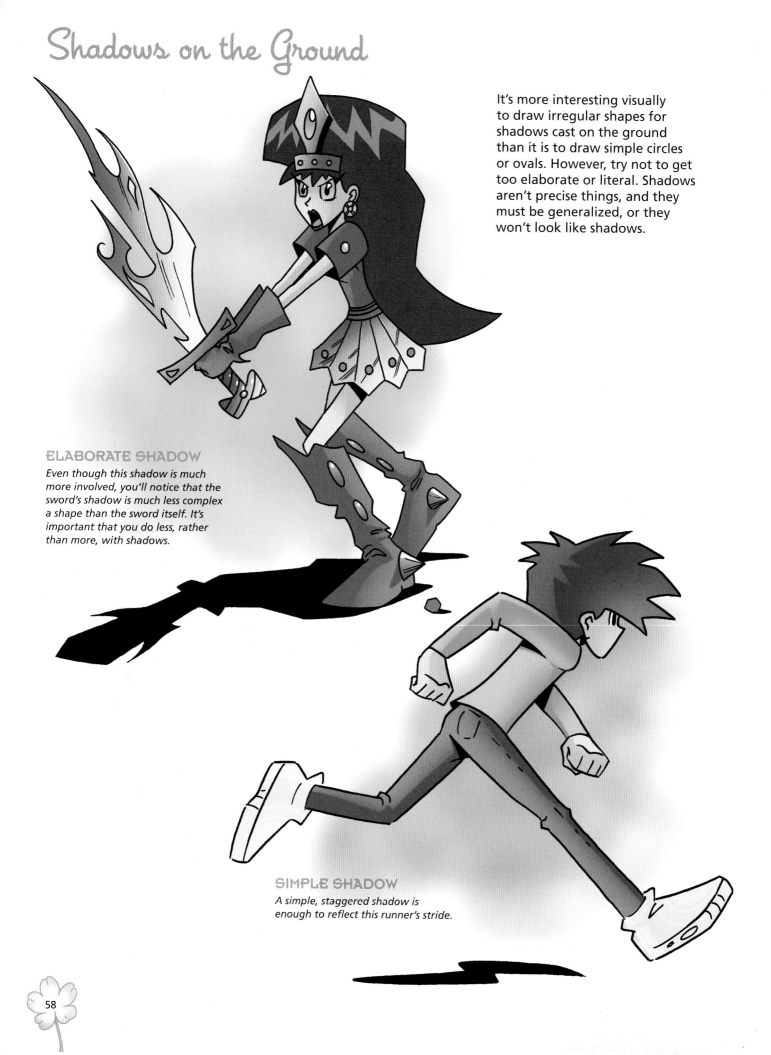

It's more interesting visually to draw irregular shapes for shadows cast on the ground than it is to draw simple circles or ovals. However, try not to get too elaborate or literal. Shadows aren't precise things, and they must be generalized, or they won't look like shadows.

ELABORATE SHADOW

Even though this shadow is much more involved, you'll notice that the sword's shadow is much less complex a shape than the sword itself. It's important that you do less, rather than more, with shadows.

SIMPLE SHADOW

A simple, staggered shadow is enough to reflect this runner's stride.

Sometimes, it's more impressive to draw a figure as a shadow rather than as a regular character. Shadows can be funny or scary or a combination of the two, as in this scene. Characters drawn as shadows, especially if they're impressive characters, must be elongated. They usually lose any distinct details in their form as they taper to their point of origin.

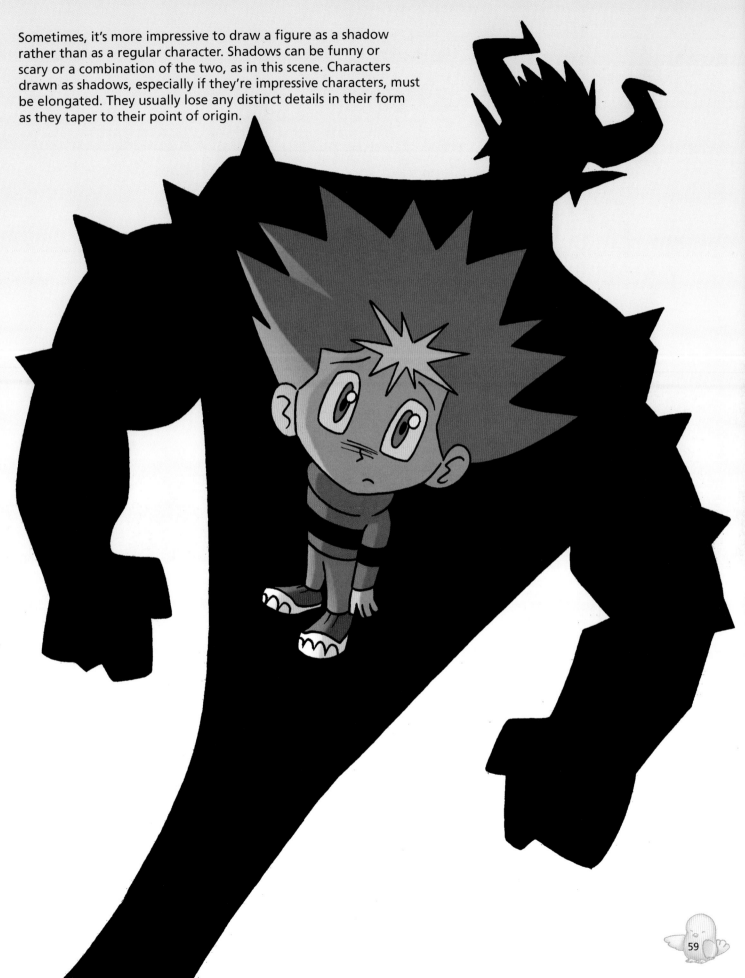

BISHIES:
THE HANDSOME YOUNG MEN OF SHOUJO

Bishie is the English abbreviation of *bishounen* (or *bishonen*), which means "beautiful young boy" in Japanese. Bishies are the young girl's idealized version of a perfect guy. Bishies are not especially masculine, which might prove too threatening to a young reader. Instead, bishies are the "pretty boys" with whom young girls fall in love. They are very popular characters in shoujo and appear in many stories.

Bishie Basics

The bishie eye is narrower and sleeker than the big eyes of other shoujo characters. The nose is longer, and usually, the bridge of the nose is drawn in, whereas on many other shoujo characters, only the tip of the nose is drawn in. The jawline is also sleeker; in fact, the whole head is narrower. In addition, bishies also appear to be more mature than other shoujo characters. Bishie hair is always flowing in the breeze—even when there's no wind! Remember, you're drawing a romanticized version of a teenage boy.

Since the character is slightly older than the other shoujo characters, the eyes appear higher up on the head—almost at the halfway point. Concentrate on drawing elegant eyes and eyebrows. Long eyelashes and dark eyelids on a boy? Yes, if the character is a bishie, it's a must.

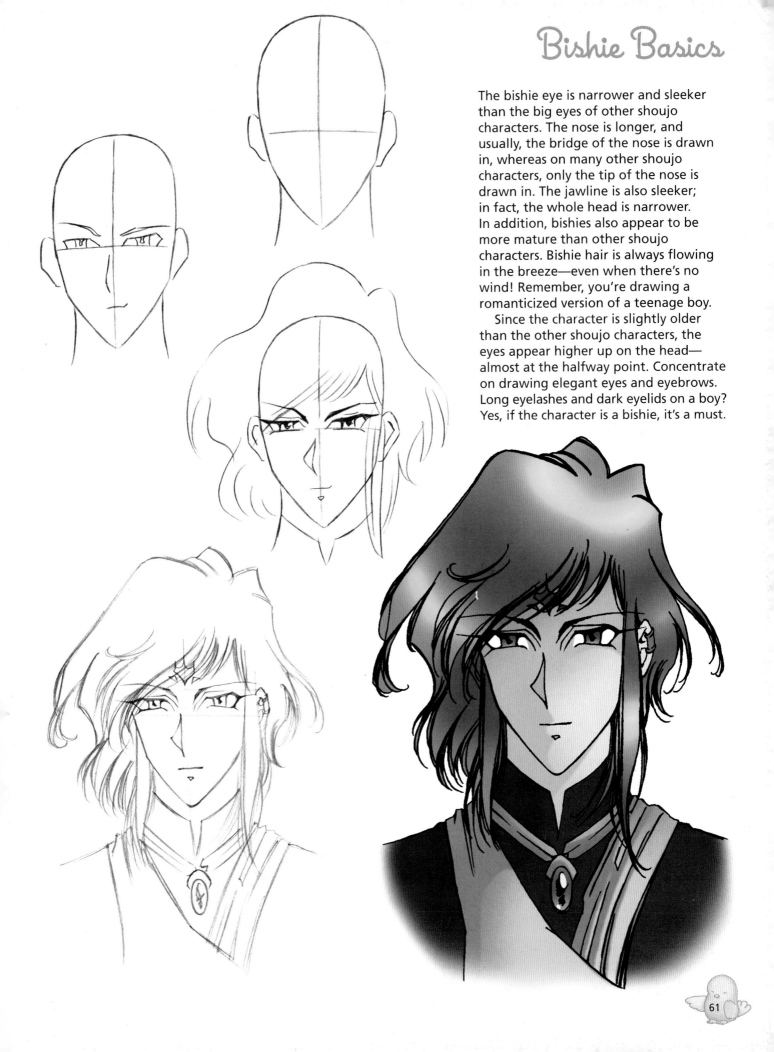

Bishie Profile

You can clearly see how long the nose is in the profile view. It's also quite pointy, yet it shouldn't appear big. The bishie has a small chin, in keeping with his elegant character type.

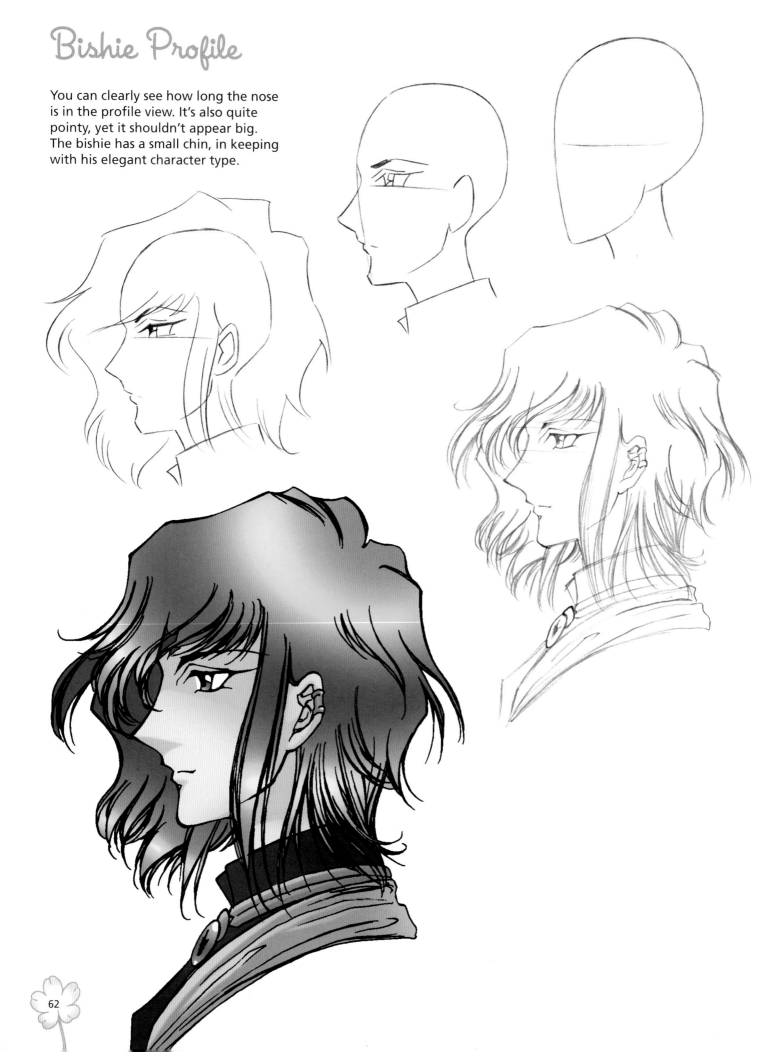

Bishie 3/4 View

The bishie's expressions are subtle and subdued, always seeming wistful and thoughtful. In this angle, you can see just how slender the chin really is. The hair falls not only over the forehead but even in front of the ears, and sometimes in front of the eyes. The neck is full, not skinny, and the body is filled out—especially at the shoulders, giving his jacket a trendy look.

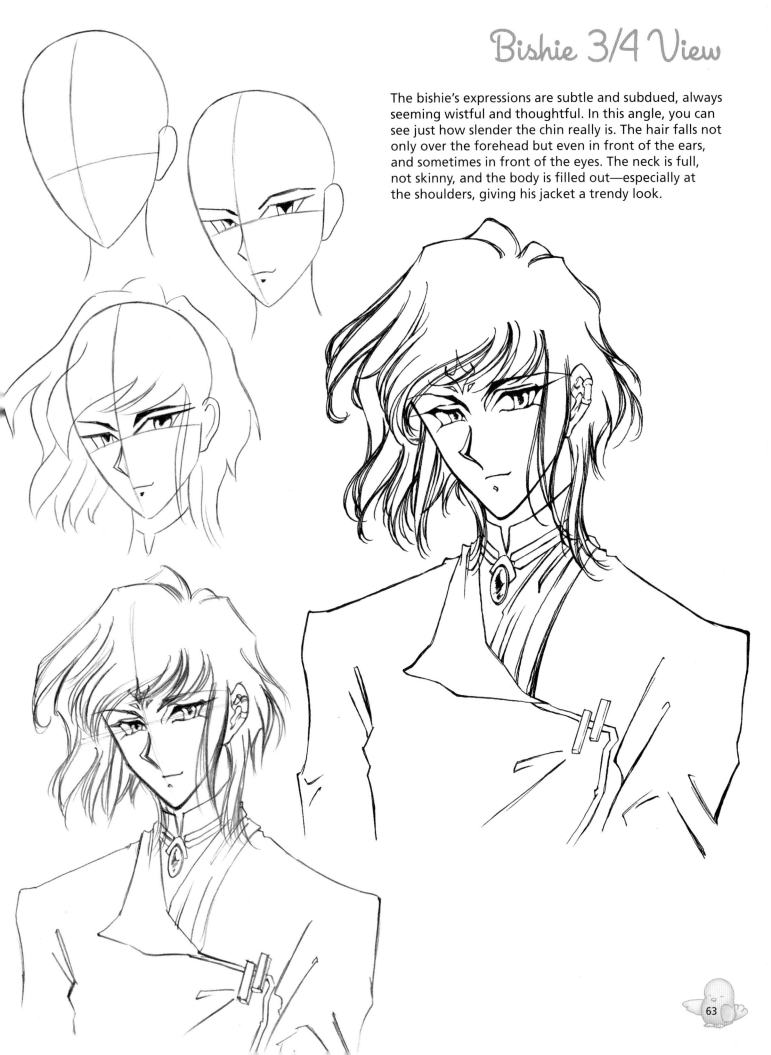

Bishie Eyes

There are many ways to draw bishie eyes. The overall shape is more horizontal than vertical; it is narrow, but long. The eyes also have pronounced shines. The eyelids look as though a bucket of mascara was applied to them.

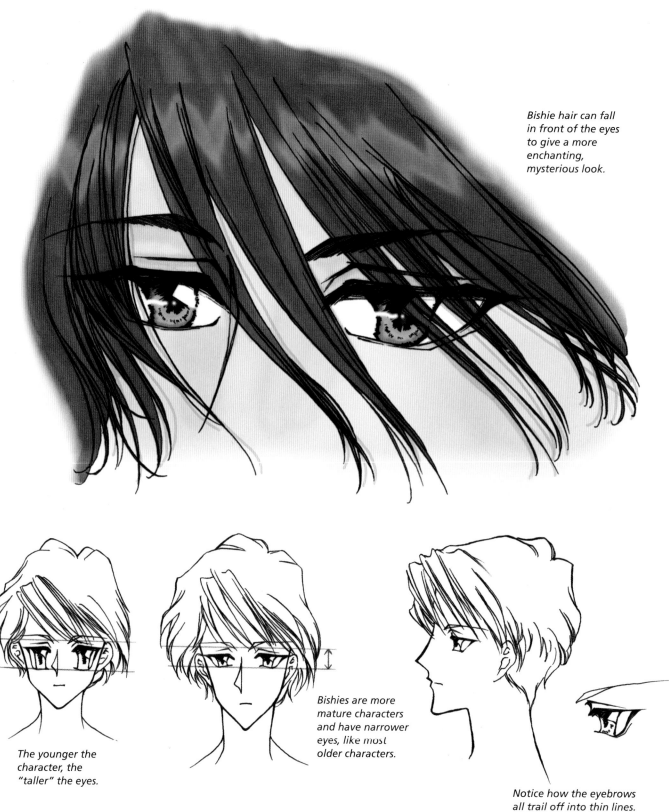

Bishie hair can fall in front of the eyes to give a more enchanting, mysterious look.

The younger the character, the "taller" the eyes.

Bishies are more mature characters and have narrower eyes, like most older characters.

Notice how the eyebrows all trail off into thin lines.

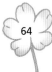

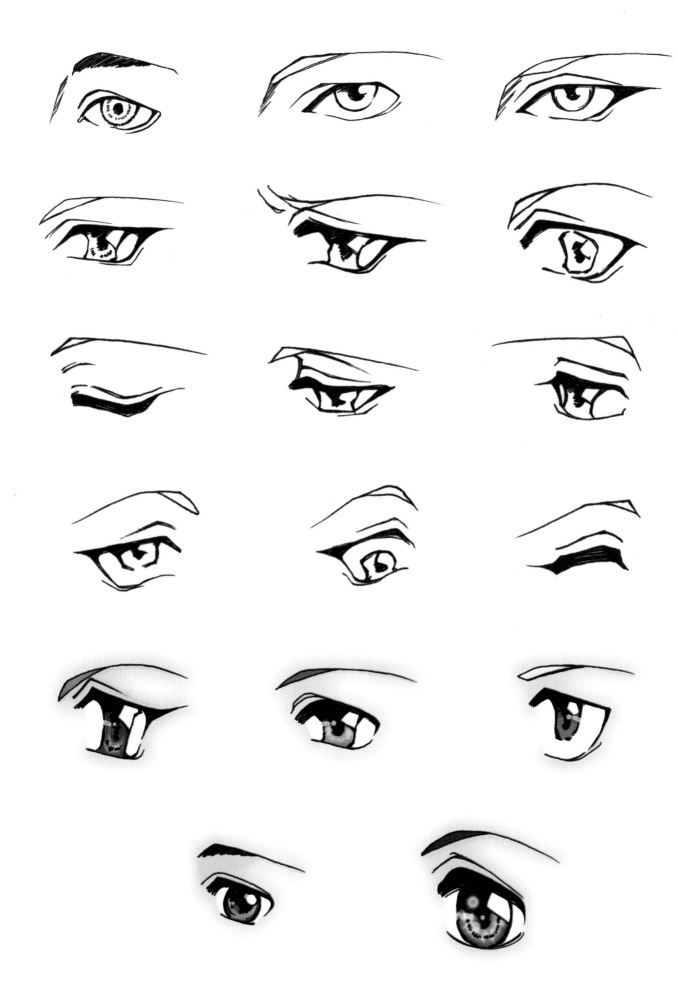

The Bishie Body

Bishies have long, leggy bodies. But, even though their faces are quite delicate, their bodies are not skinny and frail. That would make them appear weak and diminish their appeal to female readers. So, they still have wide shoulders. Their long arms and legs give them a slender appearance, and also serve to make them appear more mature. Unlike the younger shoujo characters, bishies have smaller heads in proportion to their bodies.

The body construction is very straightforward. It's all ball-and-socket joints. Keep your drawing simple, and don't be too critical of your efforts. Your drawing doesn't have to be perfect; it's the character and overall feeling that make the drawing work.

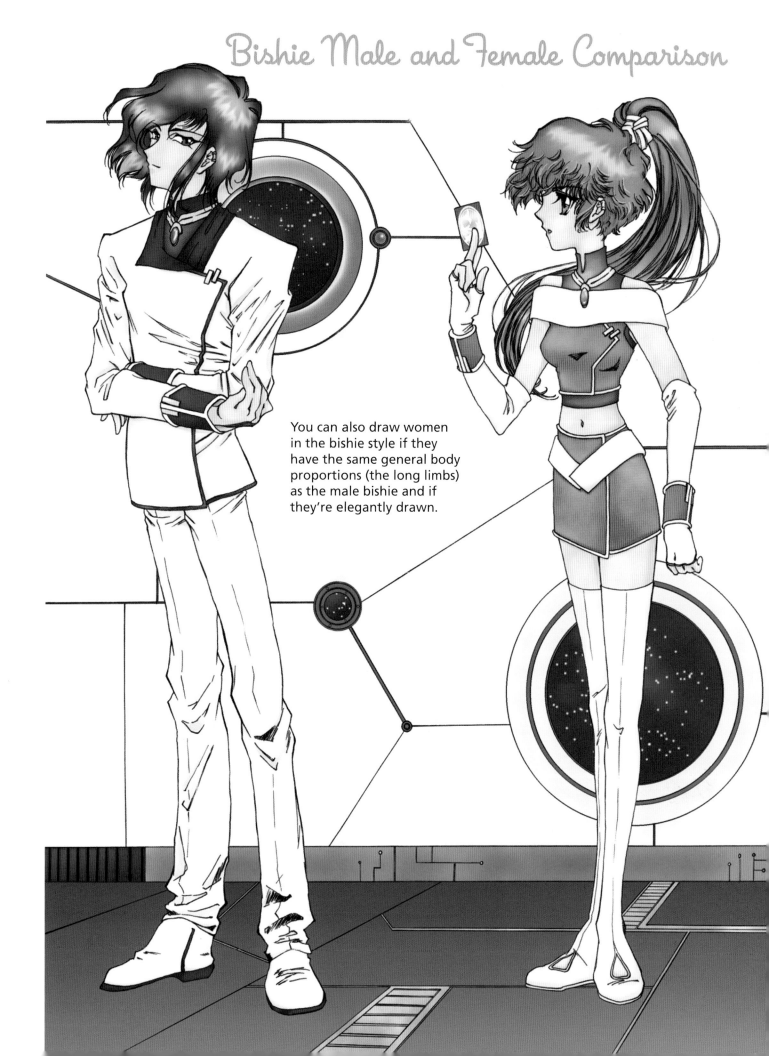

You can also draw women in the bishie style if they have the same general body proportions (the long limbs) as the male bishie and if they're elegantly drawn.

Types of Bishies

Bishies, like all characters, have different personalities. To underscore the differences between each character, you must alter his look to some extent. That's why, when you read authentic Japanese manga about bishies and there's more than one bishie in a story, you'll often find that one of them has straight hair while the other has curly or wavy hair. It's a simple way to differentiate them.

The term *bishie* refers more to a style than to a particular character. Bishies can also be fantasy creatures, semi-human and semi-animal (or even a mythological animal). The only requirement is that they be pretty and elegantly drawn.

Some of these bishies are from the Dark Side—beautiful but wicked. Vampires, demons, and zombies are examples of wicked bishies.

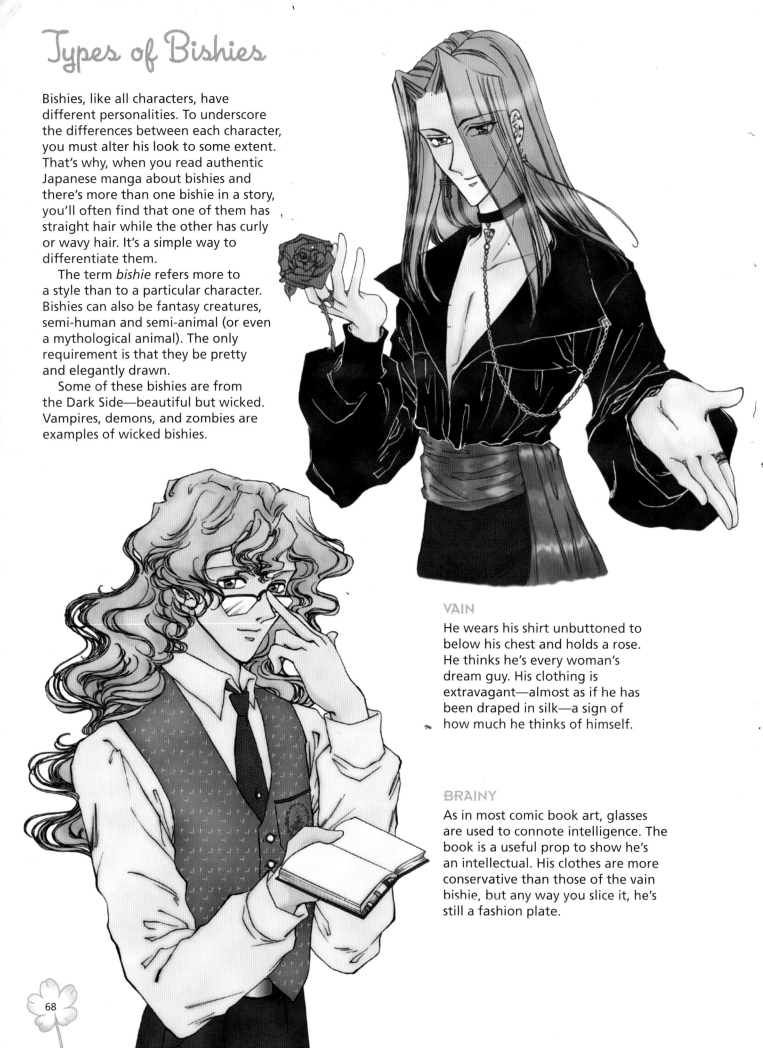

VAIN

He wears his shirt unbuttoned to below his chest and holds a rose. He thinks he's every woman's dream guy. His clothing is extravagant—almost as if he has been draped in silk—a sign of how much he thinks of himself.

BRAINY

As in most comic book art, glasses are used to connote intelligence. The book is a useful prop to show he's an intellectual. His clothes are more conservative than those of the vain bishie, but any way you slice it, he's still a fashion plate.

68

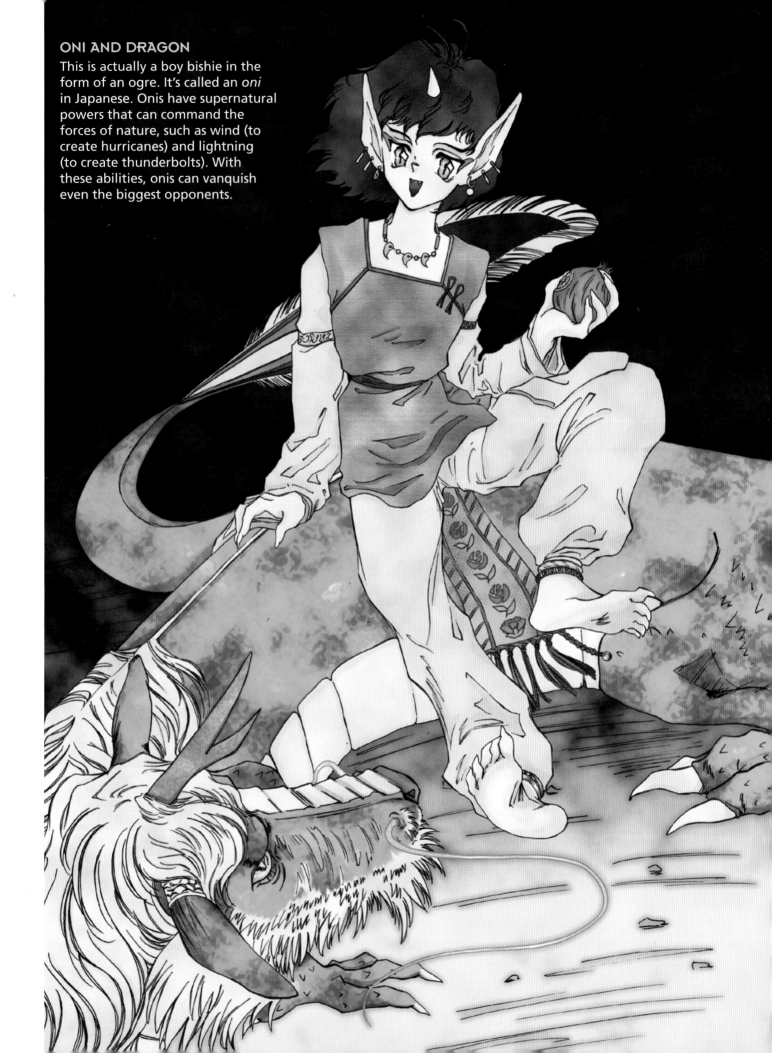

ONI AND DRAGON

This is actually a boy bishie in the form of an ogre. It's called an *oni* in Japanese. Onis have supernatural powers that can command the forces of nature, such as wind (to create hurricanes) and lightning (to create thunderbolts). With these abilities, onis can vanquish even the biggest opponents.

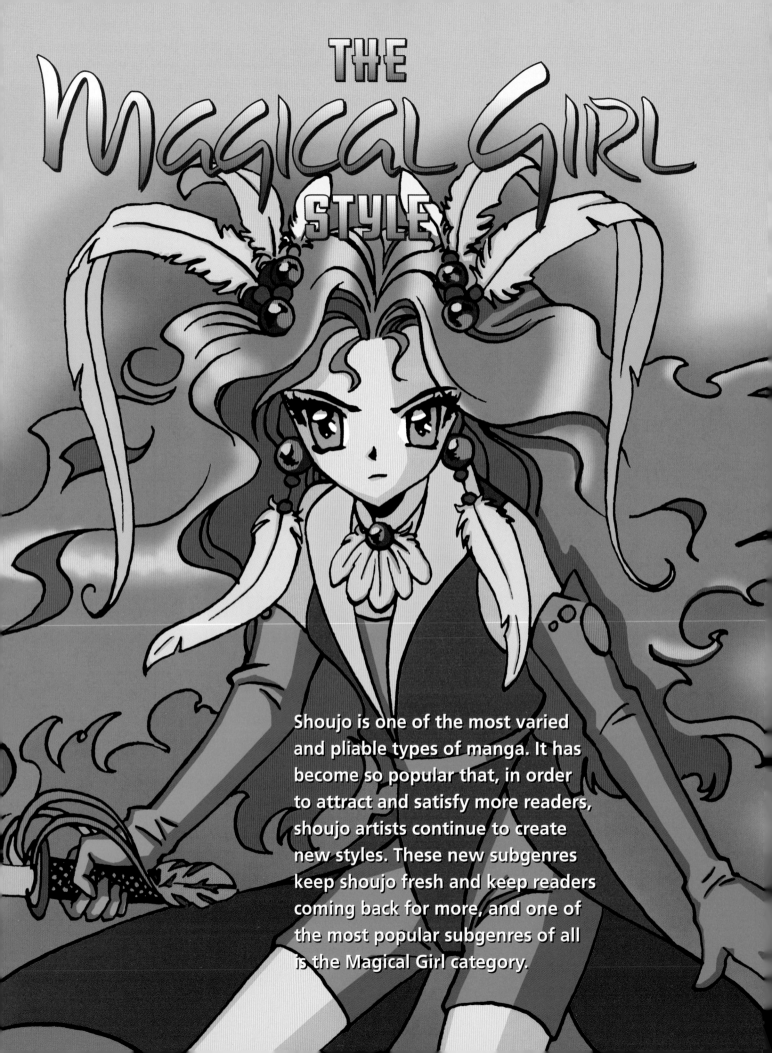

THE MAGICAL GIRL STYLE

Shoujo is one of the most varied and pliable types of manga. It has become so popular that, in order to attract and satisfy more readers, shoujo artists continue to create new styles. These new subgenres keep shoujo fresh and keep readers coming back for more, and one of the most popular subgenres of all is the Magical Girl category.

When a magical girl transforms from a normal girl into her magical self, the drawings become elaborate and fancy. Lots of detail is used to create a fantasy quality. The ornate approach to drawing the outfit, hair, and eyes evokes wonder and enchantment.

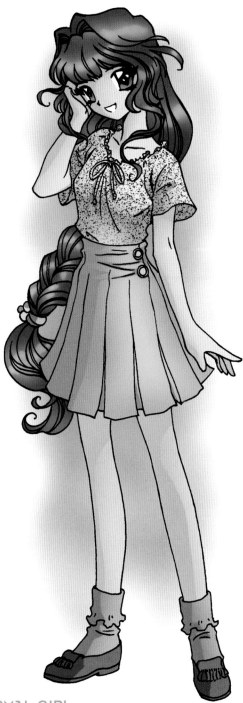

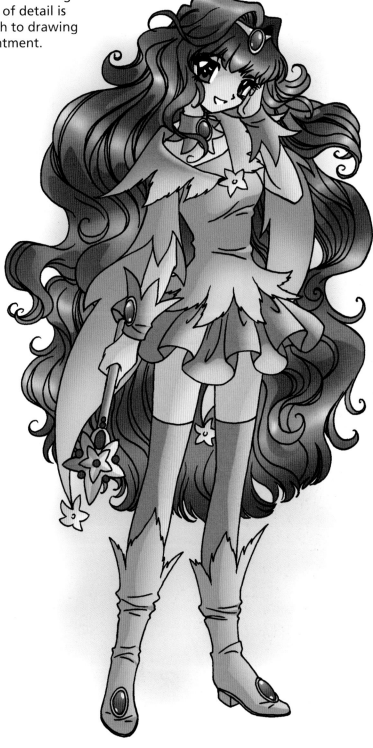

NORMAL GIRL

This is a normal girl before she transforms into a fantasy warrior. Notice that even as a normal girl, she's very detailed and elegantly drawn. If she were drawn in a simple way, her transformation into a magical girl would be too abrupt and seem like two completely different characters. The "before" and "after" versions must still look like the same character, unless your story has her changing into animals or other nonhuman creatures.

MAGICAL GIRL

We're talking about a major makeover here. The hair gets bigger, longer, and fuller—but you can still recognize its origins in the first hairstyle. The costume changes completely —but it's still based on a skirt with flounces and a short-sleeved blouse. Jewels are added (note the headpiece), a wand appears in her hand, her shoes turn into boots, and a decorative wristband appears. She is transformed.

The Magical Girl Basics

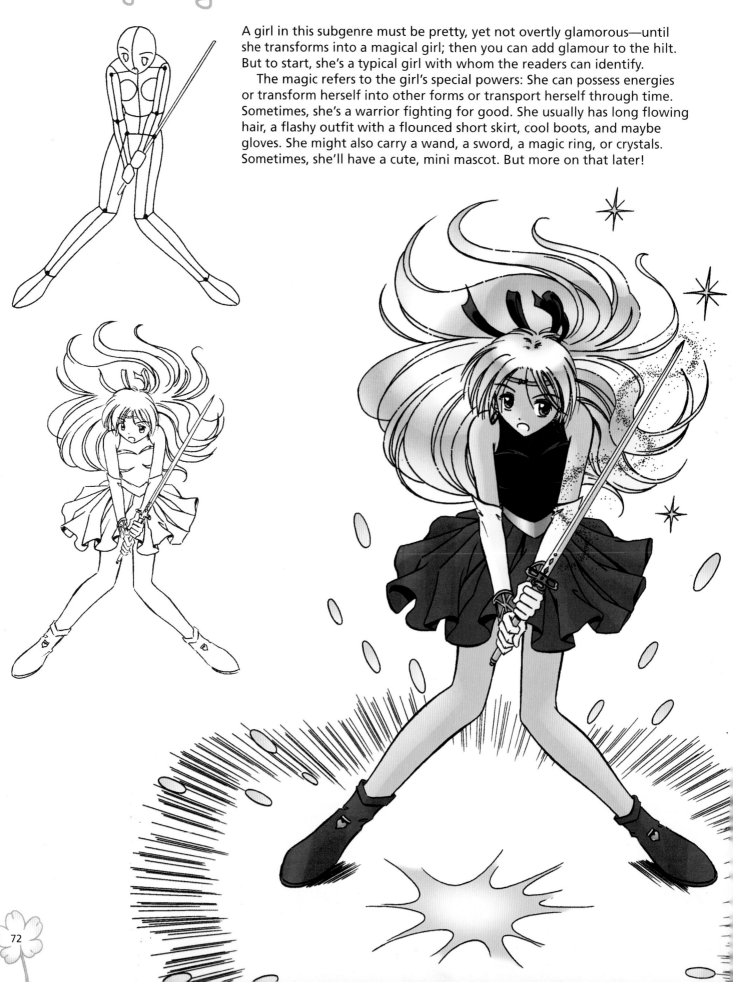

A girl in this subgenre must be pretty, yet not overtly glamorous—until she transforms into a magical girl; then you can add glamour to the hilt. But to start, she's a typical girl with whom the readers can identify.

The magic refers to the girl's special powers: She can possess energies or transform herself into other forms or transport herself through time. Sometimes, she's a warrior fighting for good. She usually has long flowing hair, a flashy outfit with a flounced short skirt, cool boots, and maybe gloves. She might also carry a wand, a sword, a magic ring, or crystals. Sometimes, she'll have a cute, mini mascot. But more on that later!

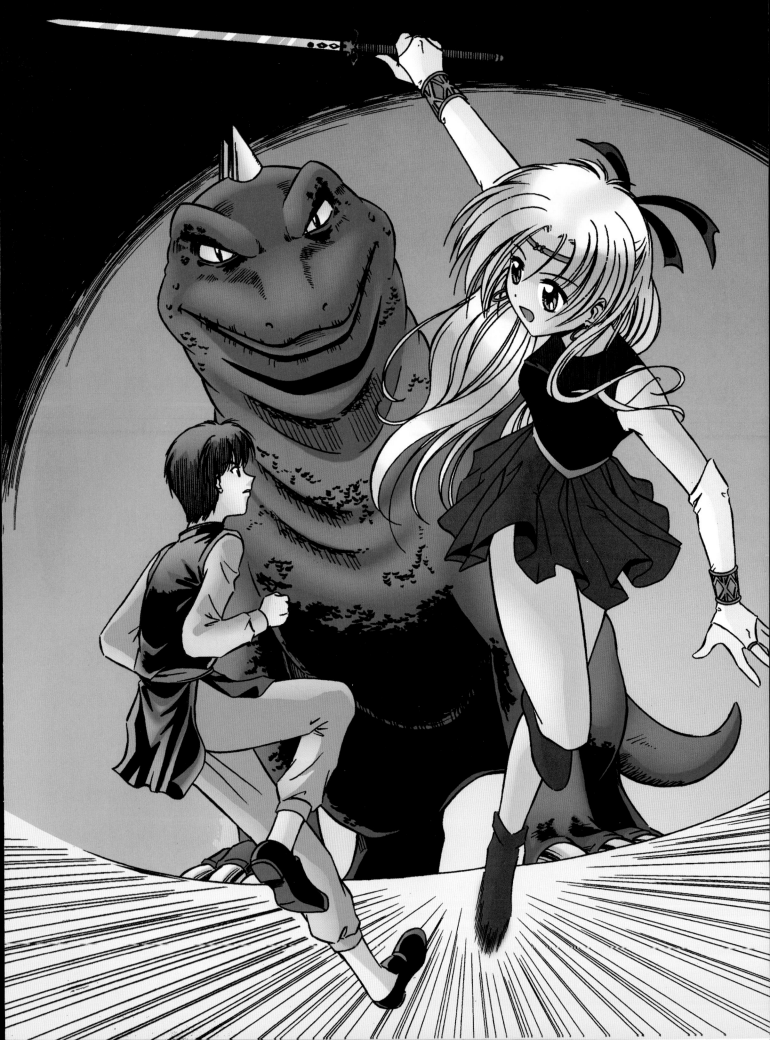

Magical Girls—and Boys

Boys play a role in the Magical Girl subgenre. Sometimes they're enemies; sometimes they're friends. Many times the boys fight on the same side as the girls against a common enemy. They can have magical powers of their own but not as much as a magical girl. After all, there can only be one star.

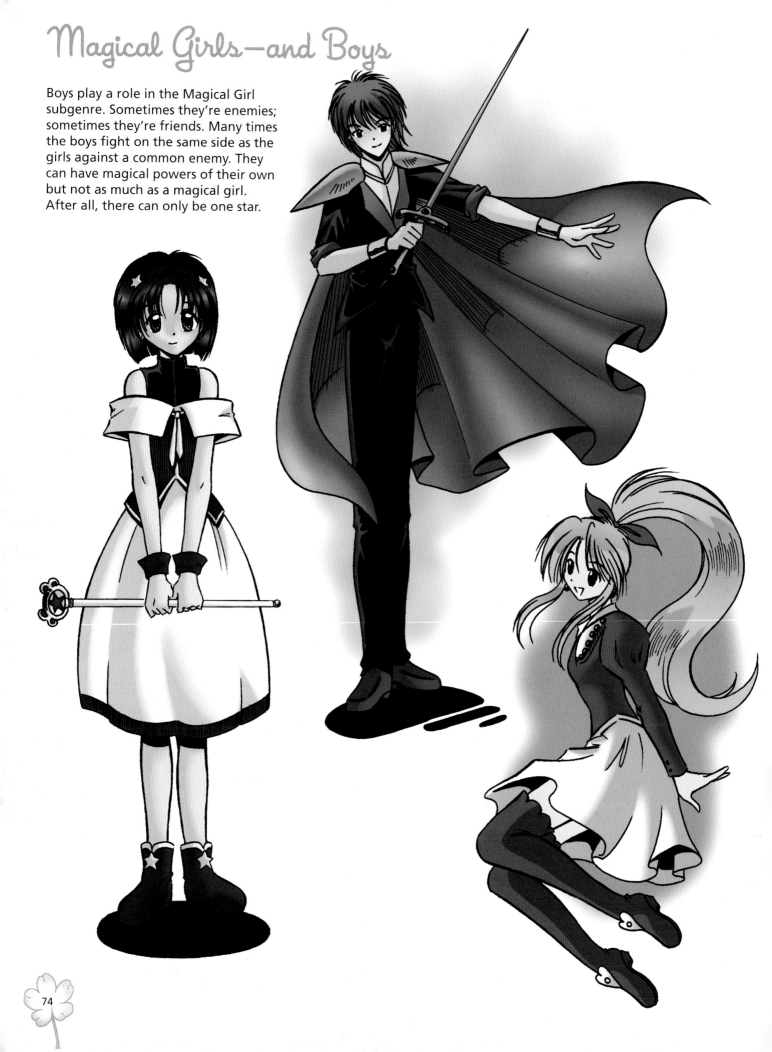

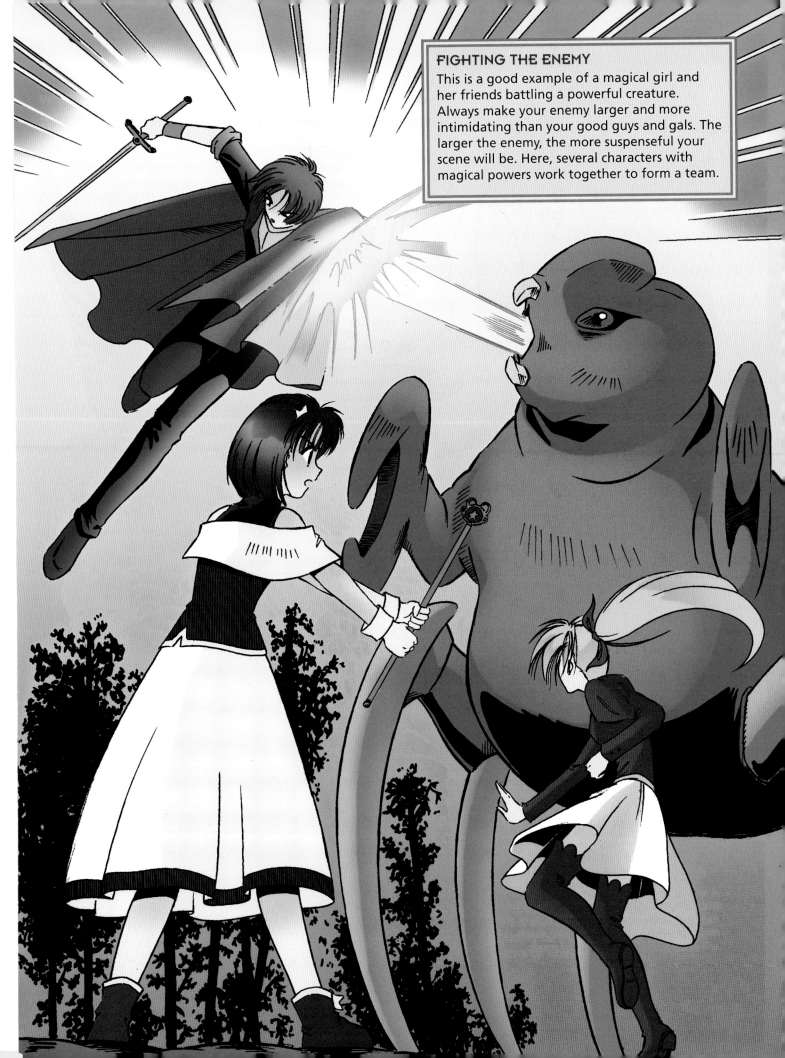

FIGHTING THE ENEMY
This is a good example of a magical girl and her friends battling a powerful creature. Always make your enemy larger and more intimidating than your good guys and gals. The larger the enemy, the more suspenseful your scene will be. Here, several characters with magical powers work together to form a team.

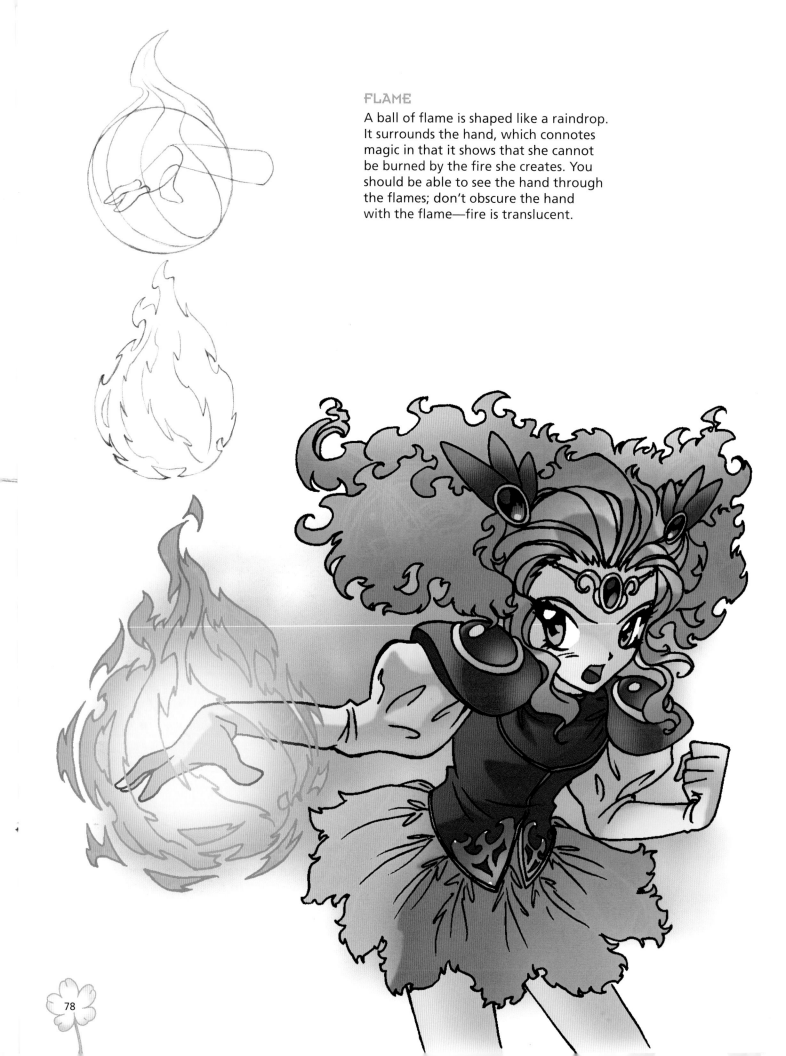

FLAME

A ball of flame is shaped like a raindrop. It surrounds the hand, which connotes magic in that it shows that she cannot be burned by the fire she creates. You should be able to see the hand through the flames; don't obscure the hand with the flame—fire is translucent.

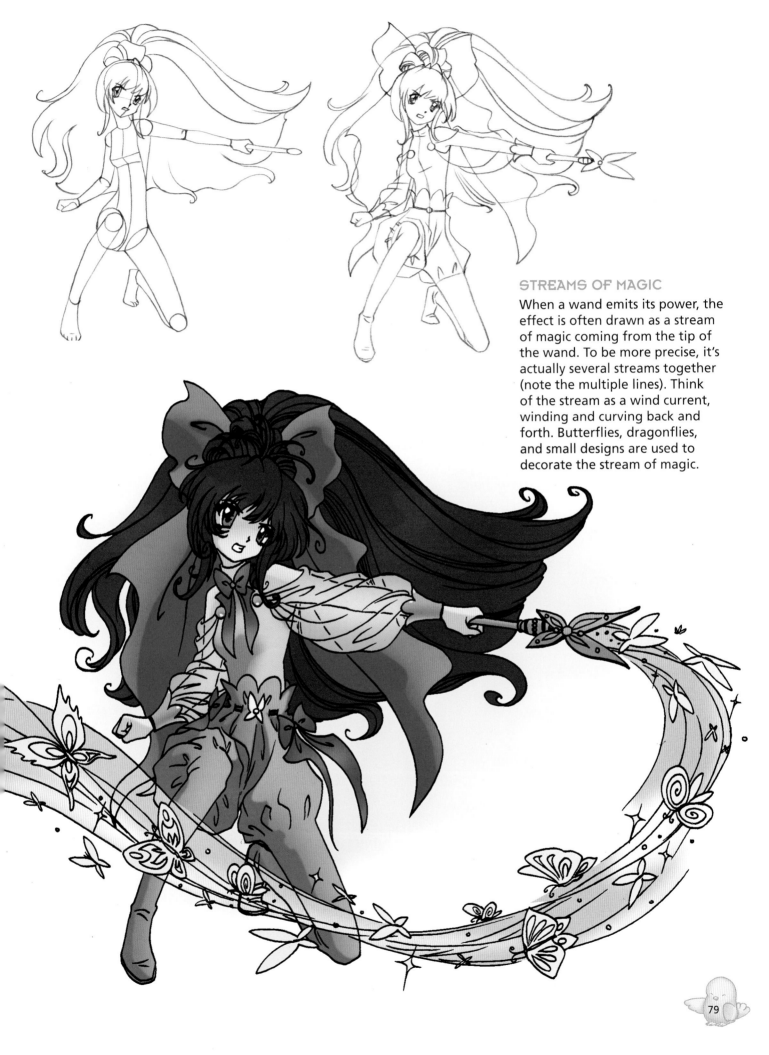

STREAMS OF MAGIC

When a wand emits its power, the effect is often drawn as a stream of magic coming from the tip of the wand. To be more precise, it's actually several streams together (note the multiple lines). Think of the stream as a wind current, winding and curving back and forth. Butterflies, dragonflies, and small designs are used to decorate the stream of magic.

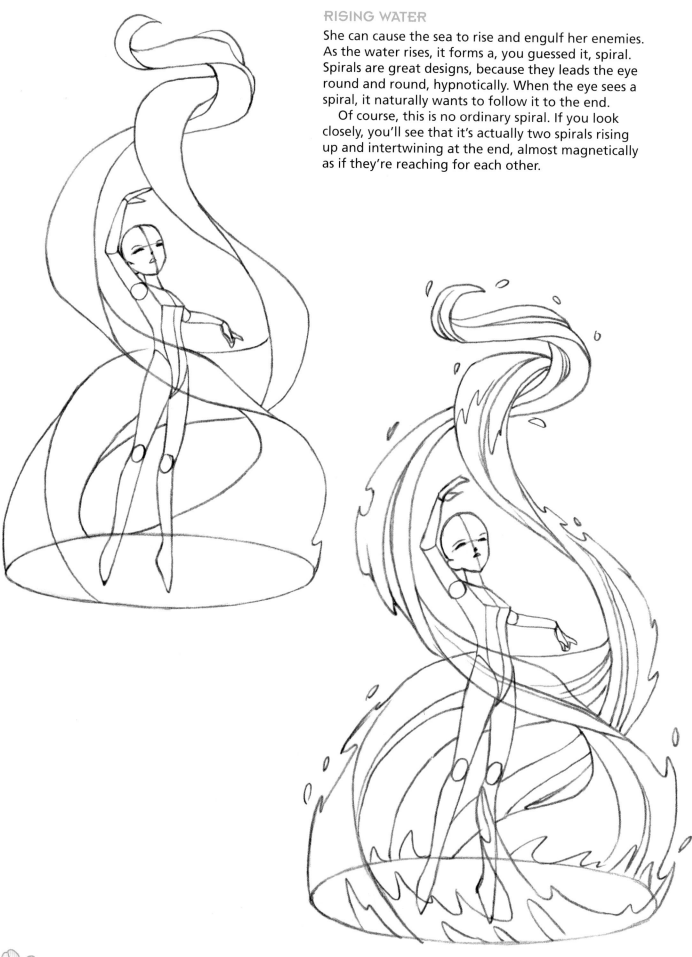

RISING WATER

She can cause the sea to rise and engulf her enemies. As the water rises, it forms a, you guessed it, spiral. Spirals are great designs, because they leads the eye round and round, hypnotically. When the eye sees a spiral, it naturally wants to follow it to the end.

Of course, this is no ordinary spiral. If you look closely, you'll see that it's actually two spirals rising up and intertwining at the end, almost magnetically as if they're reaching for each other.

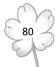

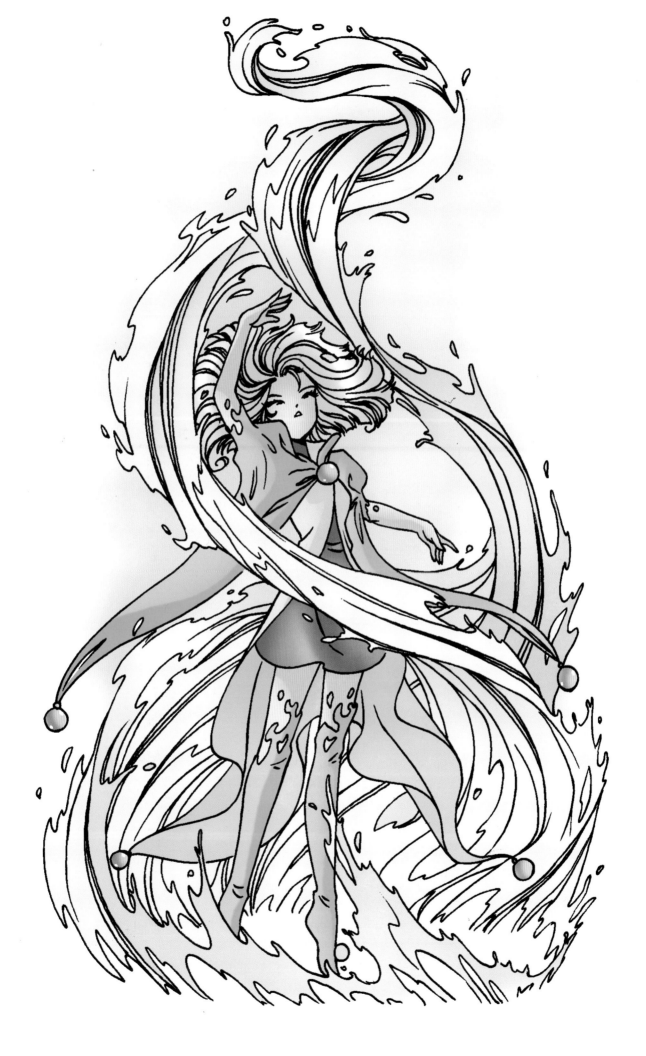

Not all magic is represented by a literal thing, like fire or water. Sometimes, an intricate, bizarre design will convey the idea just as well—or even better. This approach works when the magic is not supposed to *do* anything, such as attack an enemy, but instead is a symbol that something magical is about to happen.

For example, this magical figure might be starting a spell that will result in the creation of a giant ogre. A stream of magic or a spiral of water would be too specific for such an endeavor. So, you could use a crackling-energy effect like the one here to launch such a creature.

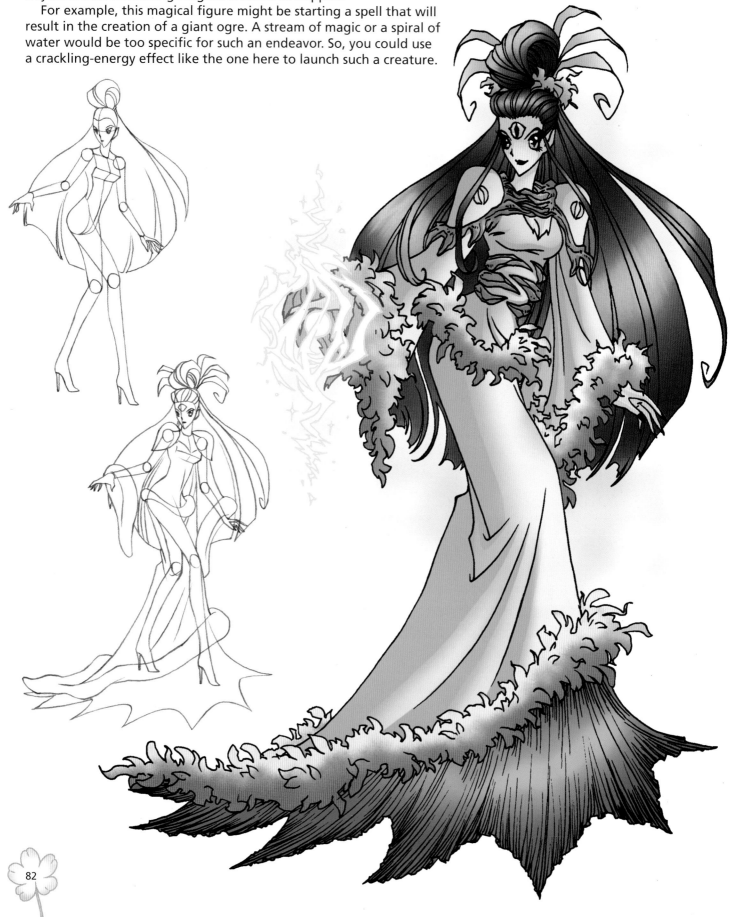

The Magical Girl realm can also feature other characters with magical qualities, provided you draw them in an elegant manner. This creature is the result of a magical transformation.

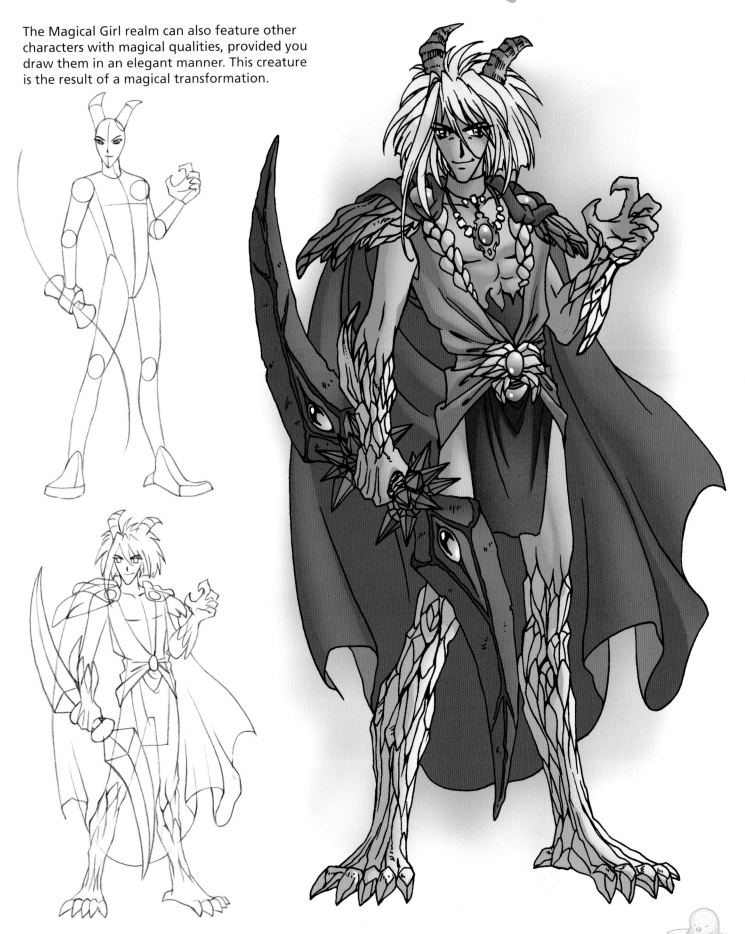

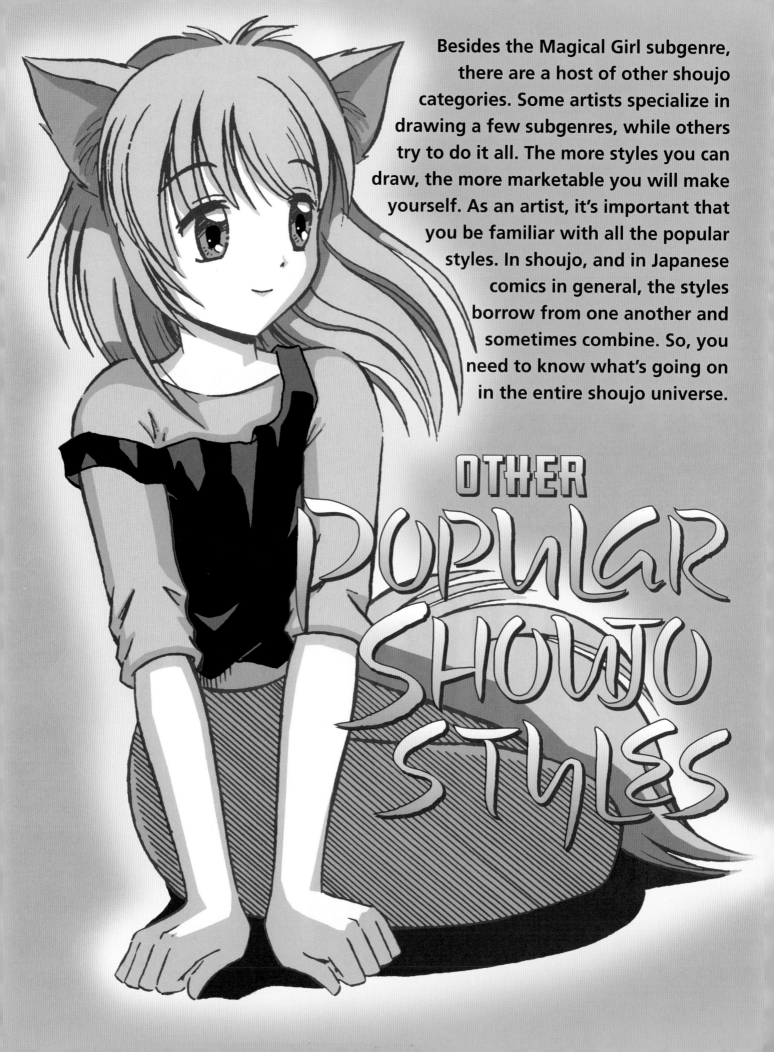

Besides the Magical Girl subgenre, there are a host of other shoujo categories. Some artists specialize in drawing a few subgenres, while others try to do it all. The more styles you can draw, the more marketable you will make yourself. As an artist, it's important that you be familiar with all the popular styles. In shoujo, and in Japanese comics in general, the styles borrow from one another and sometimes combine. So, you need to know what's going on in the entire shoujo universe.

OTHER POPULAR SHOUJO STYLES

Japan rocks! Pop singers are huge in Japan, so it's no wonder that an Idol Singers subgenre has become all the rage. And, when combined with the Magical Girl subgenre, it's a favorite among Japanese readers. Magical girls can transform themselves, via magic, into another form. As an example, a girl might be shy and have no talent, only a secret dream to perform. However, with her magical powers, she transforms herself into a rock star, but she must keep her true identity a secret from the other band members, the

manager, the fans, and, of course, her parents, who have no idea that she is performing at night .

You can come up with other scenarios for your own Idol Singer/Magical Girl story. Maybe you could reverse it and make her a rock star who wants to see what life is like for normal people. She would use her magic to transform herself into a schoolgirl, but she must keep her secret from her teachers and classmates, one of whom turns out to be her biggest fan. The possibilities are endless.

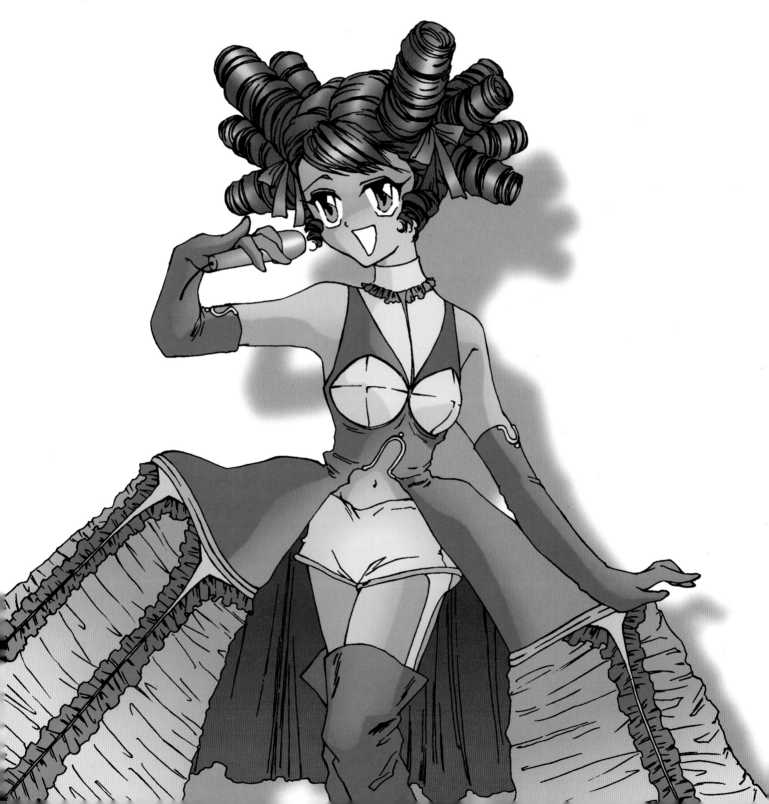

Fantasy/Adventure

This is the sword-and-sorcery subgenre of shoujo, and it is very popular, especially when it features elfin creatures and faeries. Most often, it involves a normal human girl who is kidnapped by evil forces and brought to the faerie realm, where she must overcome many obstacles to find her way home.

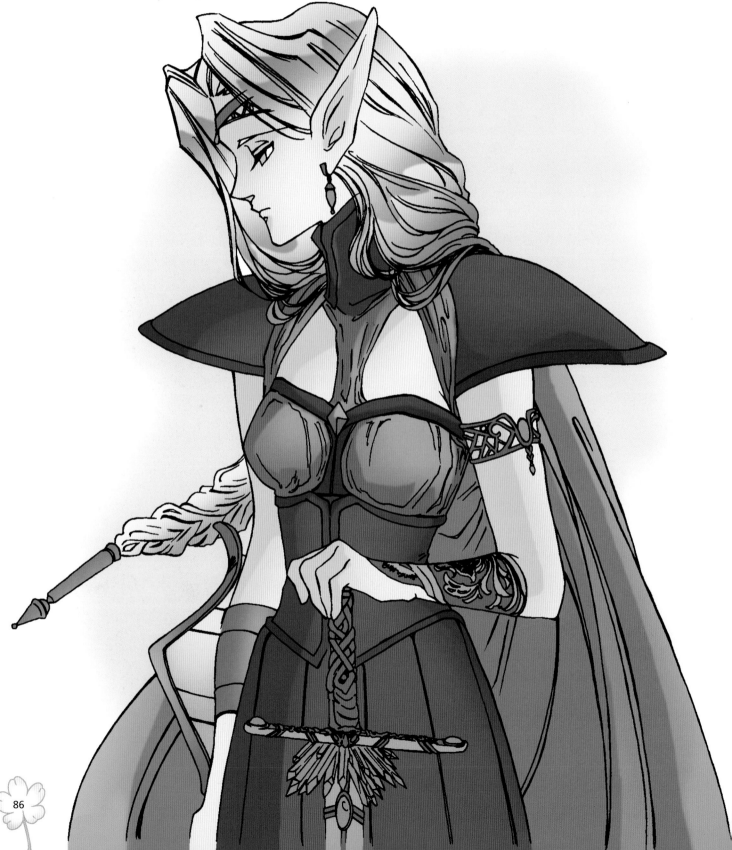

This subgenre is based on a tried-and-true formula: A losing team can't get ahead, a rookie appears, and he galvanizes the team, getting their spirits soaring. They work very hard, sweating and grunting in practices, and finally get a shot at winning the championship. It's a fight for glory, so it's always exciting.

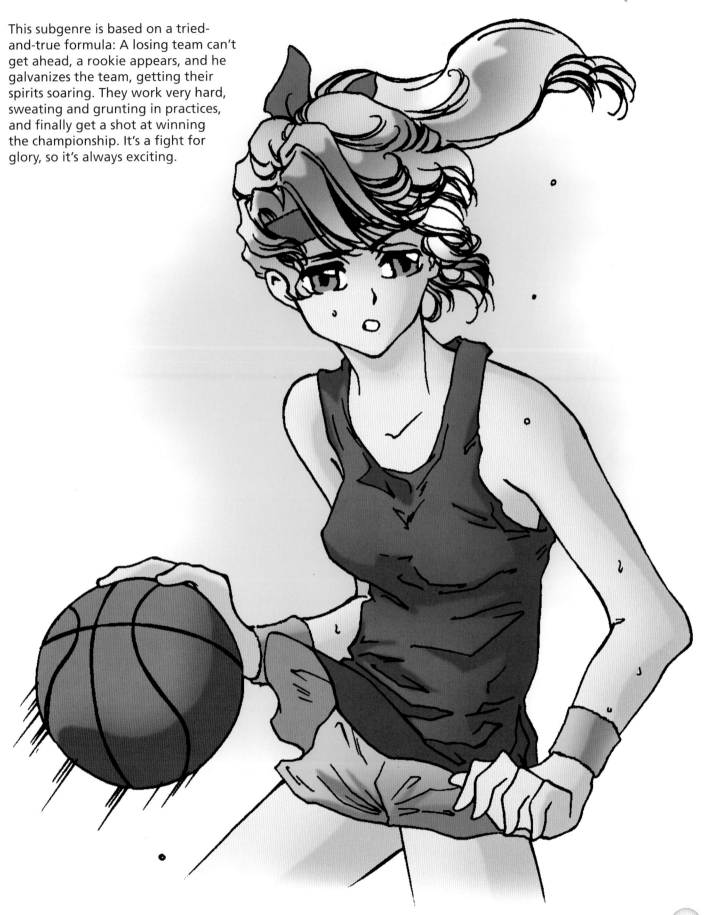

Horror

The Horror genre deals with supernatural creatures, such as vampires, ghosts, and monsters. It's a roller coaster ride, with lots of thrills and screams. As in American-style horror movies, teenagers always seem to make the best victims. And, for some reason, the kids always find themselves alone in a secluded house in the boonies at night. Boo!

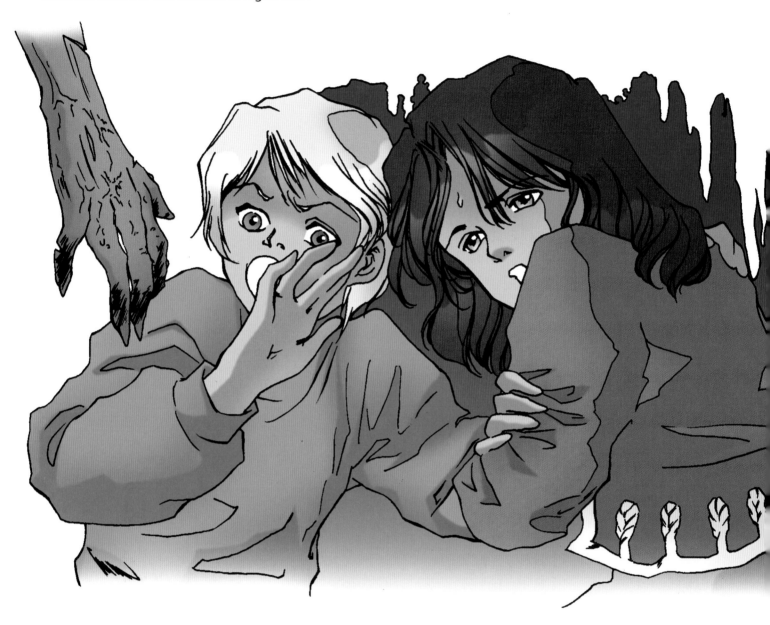

Period Dramas

These are stories set in the past. It can be anytime in the past. Of course, shoujo tends to focus a lot on Japan, but other countries and times can be depicted, as well, like Victorian England. The historical costumes create a lot of atmosphere, which is visually exciting. Research into the time period you're depicting always helps, but it isn't necessary to be completely accurate as long as the time period is clear.

Relationships in this subgenre can have similar story lines to relationships that occur in the present. For example, instead of having a girl who isn't doing well at school, you might have a girl from the nobility who is distracted from her lessons in etiquette, because she has a secret crush on a commoner.

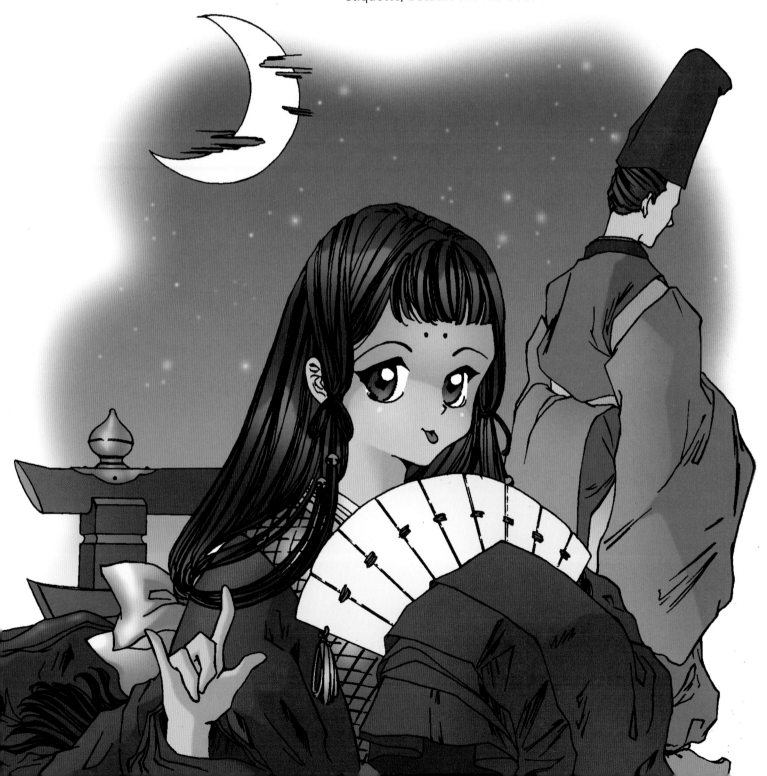

Psychic/Action

This subgenre is easy for teenagers to relate to, because it deals with people who feel like outsiders. All teenagers feel like outsiders at one time or another. These particular outsiders, however, are born with special abilities—psychic abilities—with which they grapple and which they use to combat their enemies. It's both a blessing and a curse.

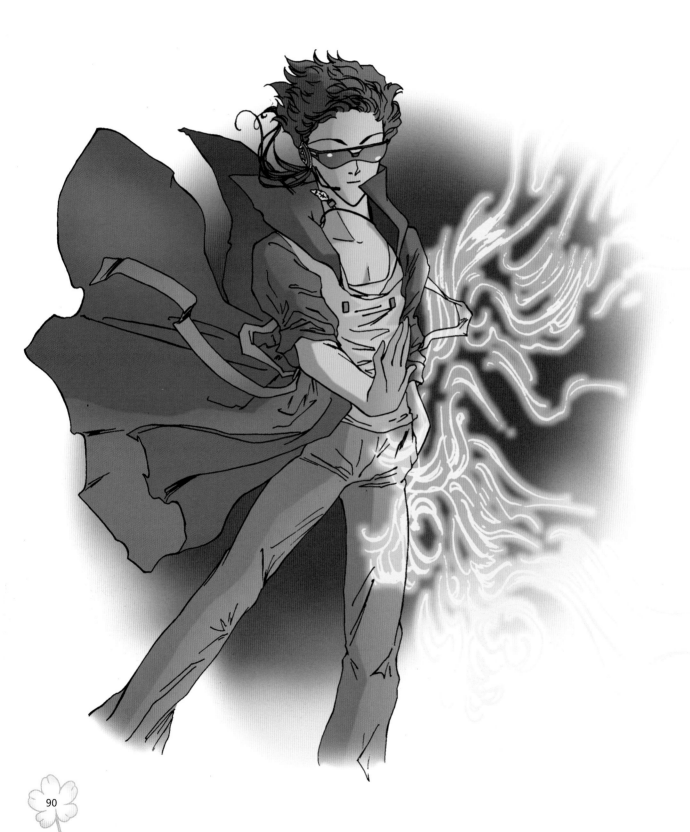

Real-Life Dramas

This is a very popular subgenre, because it's really like a soap opera for teenagers. It doesn't deal with tremendous battles or fights between good and evil. Instead, it deals with relationships, socializing, the cliques, gossip, and so on—you know, the things that go on in a teenager's life. This is an example of the type of story you rarely find in American comics.

Uniformed Workers

Another popular subgenre of shoujo deals with professions that require uniforms, such as nursing. The character is usually a female who works as a service provider. She's caring and nurturing. She should be quickly recognizable by a piece of clothing unique to her profession. For example, the nurse's hat is unlike any other and quickly pegs her as a health care professional. Her all-white outfit and clipboard complete the look.

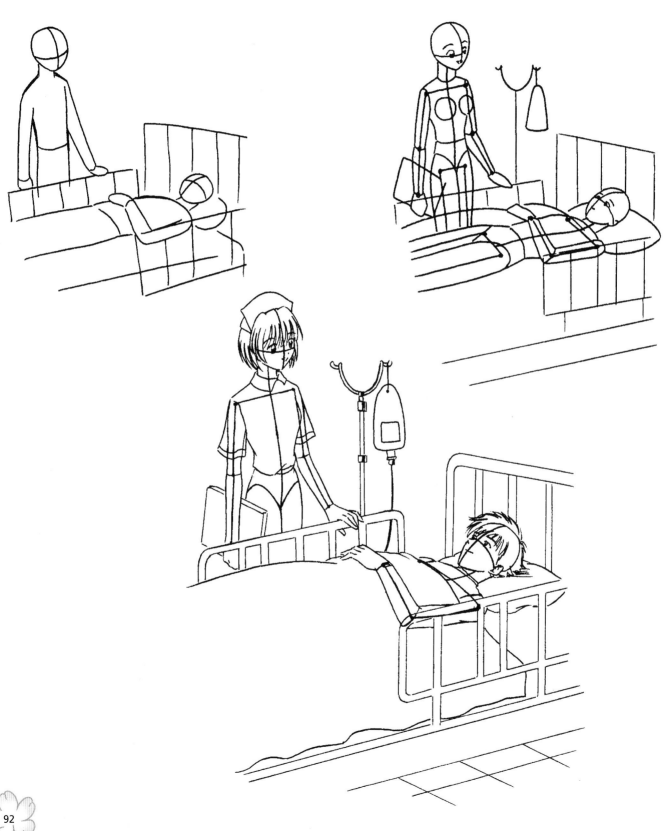

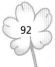

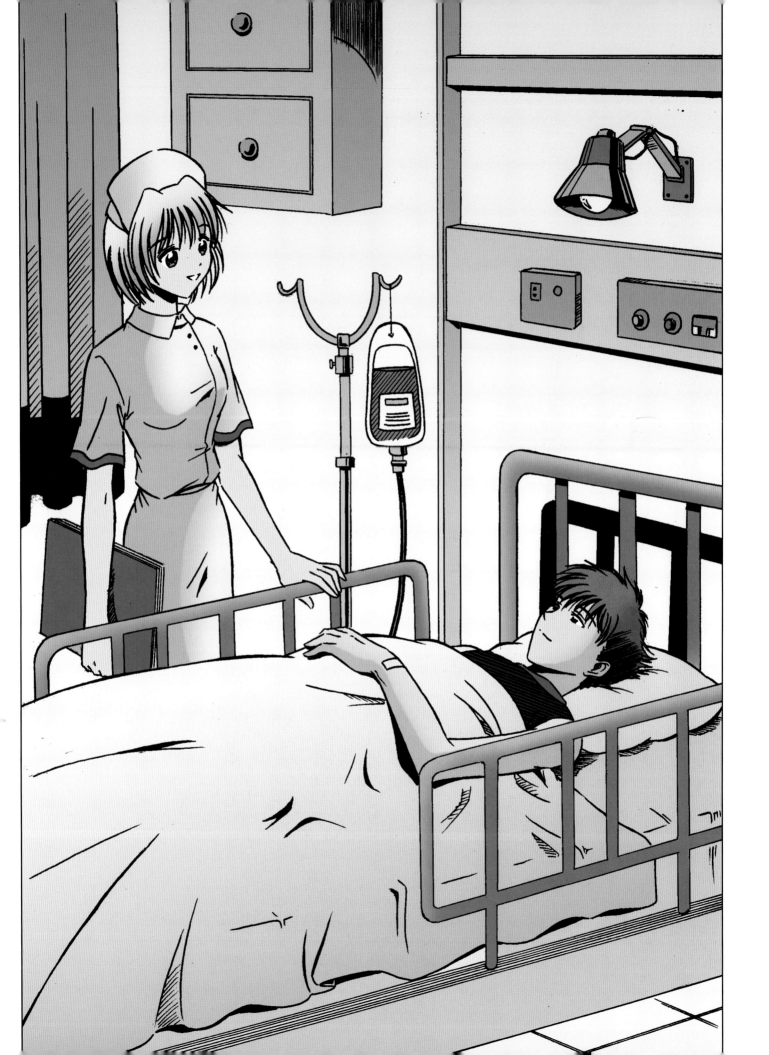

Samurai

Chances are, there weren't many female teenage samurai in the olden days. But, since samurai are such popular—almost mythical—characters, it's only natural that a martial arts subgenre would find its way into shoujo.

The essential elements of the samurai outfit are the headscarf, heavy canvas top with huge sleeves, billowing pants (which are usually darker), sash (or *obi*), sandals, and sword. Note that the sword is not the type used by medieval knights; it's thinner and lighter and, therefore, used to deliver a series of lightning-fast strikes. Knights' swords are thicker and heavier to slash through armor.

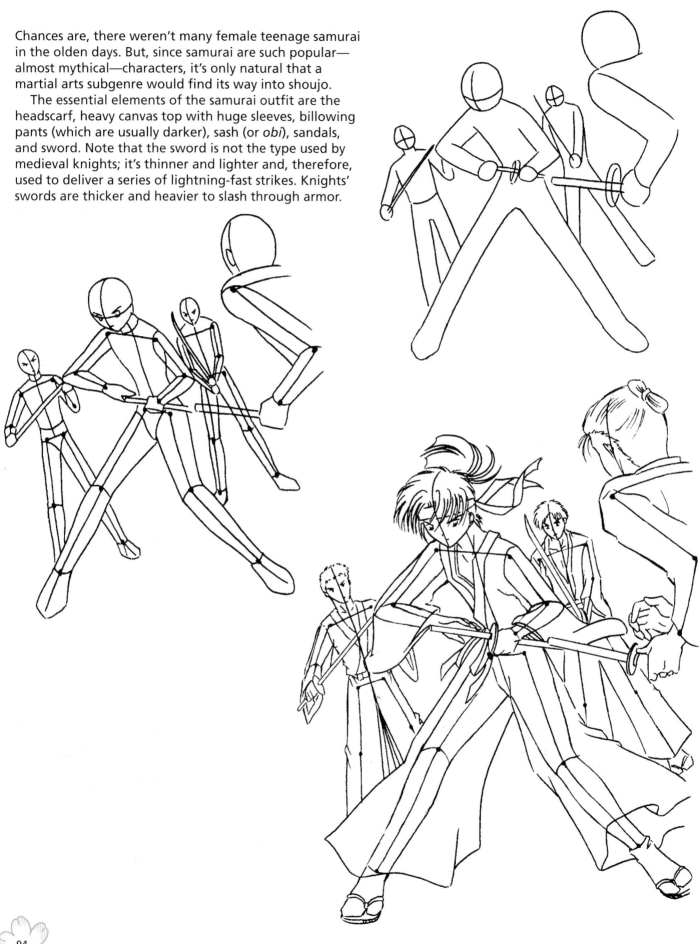

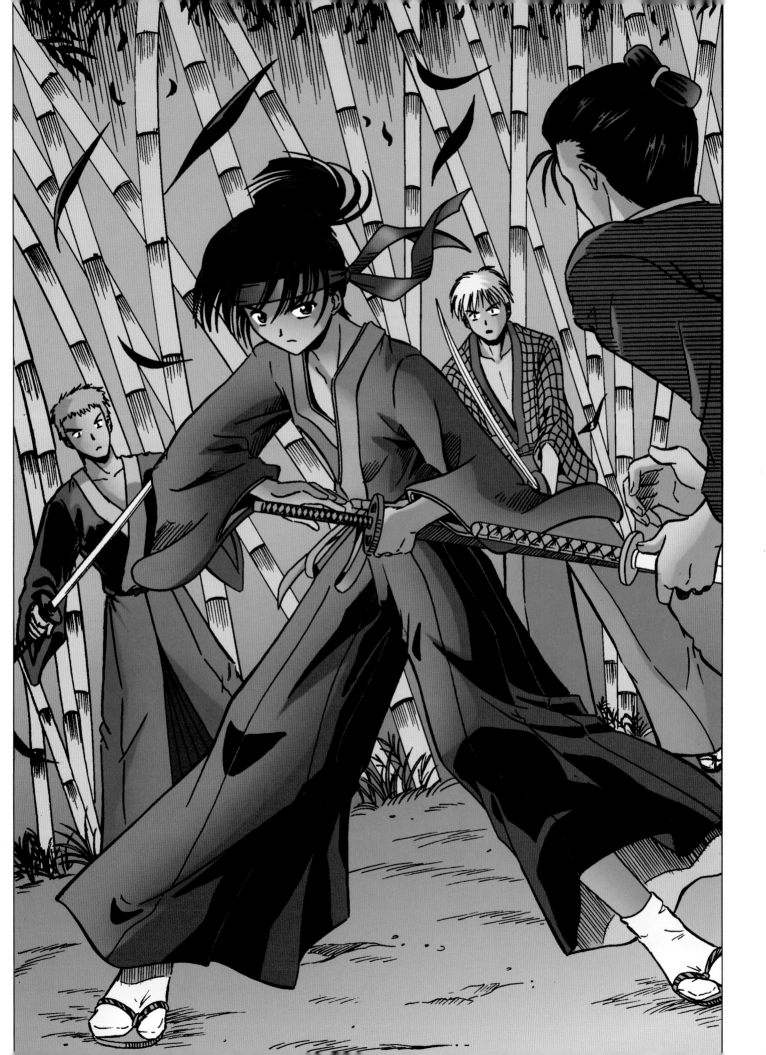

School Kids

School-age characters make up a large portion of shoujo manga. It's a hugely popular subgenre because everyone relates to it, since everyone has had some school experiences. Plus, schools are microcosms of relationships in general. In school, you'll find popular boys, cliquey girls, gossips, outcasts, bullies, authority figures, rebels, and more. In addition, other shoujo subgenres can originate from the school environment, whether it's bishies or magical girls.

In Japan, where school uniforms are the norm, school kids have a recognizable look. Their uniforms become de facto costumes, creating a unifying theme among the characters. When drawing groups of school kids, be sure to vary the hairstyles and expressions, so the characters won't look like clones.

Schools are great locations for stories because they offer familiar settings in which people congregate and interact: lockers, gym class, bike rack, cafeteria, etc.

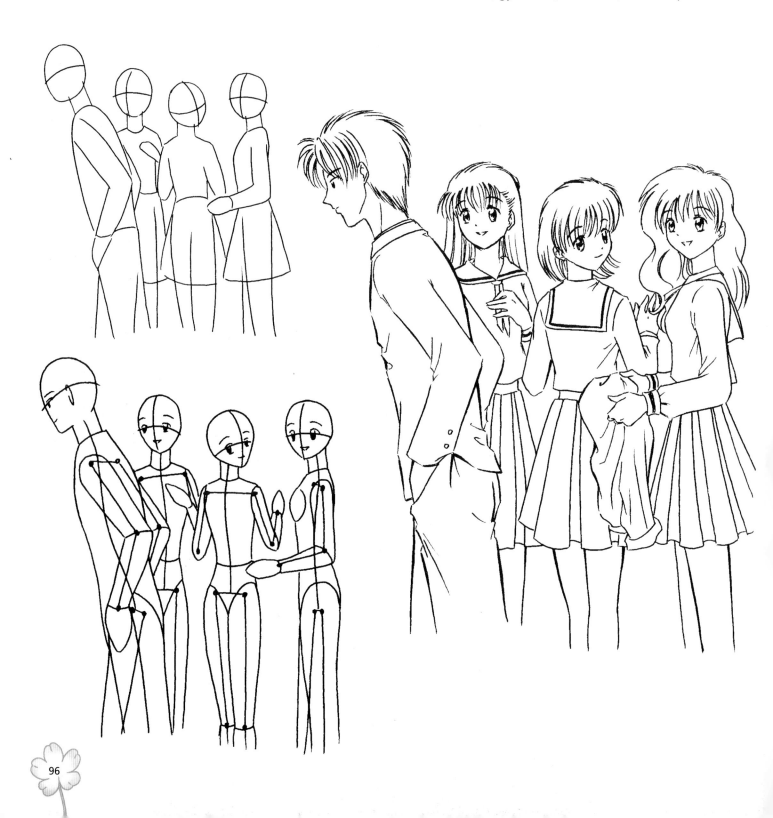

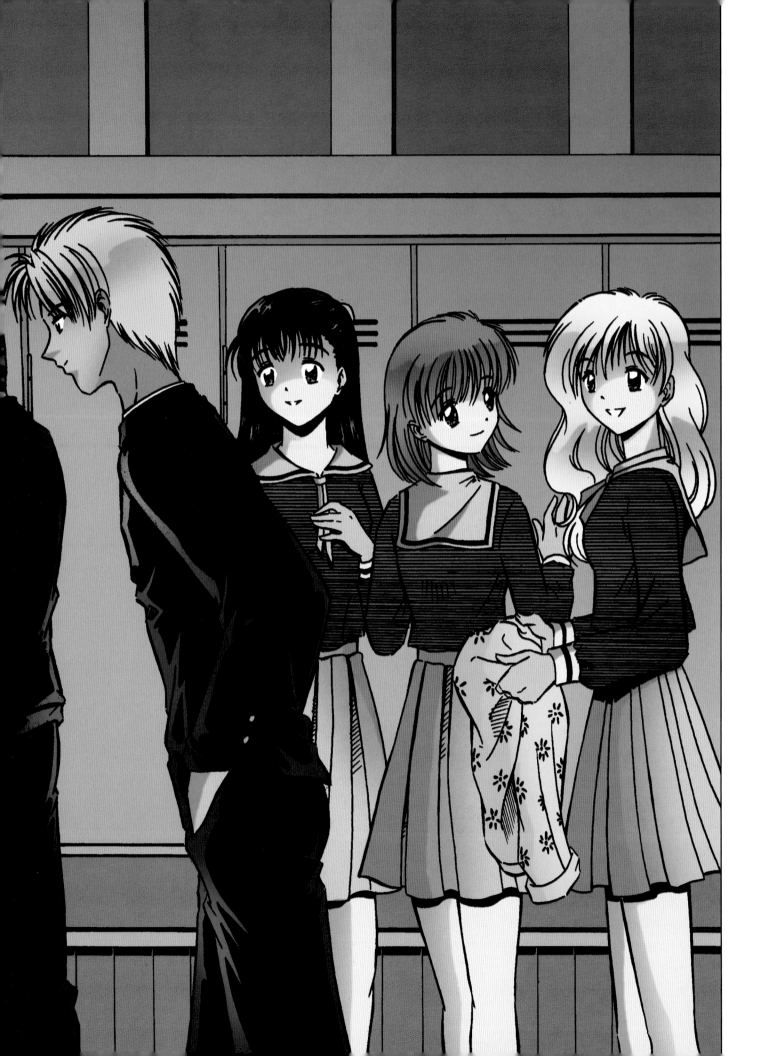

School Kids without Uniforms

School kids don't always wear uniforms. Some schools don't require them. There's also after-school play, weekends, holidays, vacations, and summer. Too often, beginning artists are so concerned with getting the look of the face right that they forget that clothes are an integral part of the character design. As anyone with teenage or tweenage (between 10 and 12 years) kids will tell you, teenagers will not wear just anything. It may look casual, even sloppy, but it's always a conscious statement. So, when drawing a teen or tween school kid, make sure the clothes represent what kids are wearing today.

BANDANA AND BOATNECK TOP

BACKWARD CAP, OVERSIZED PANTS, AND OPEN UNTUCKED SHIRT

BOMBER JACKET AND JEANS

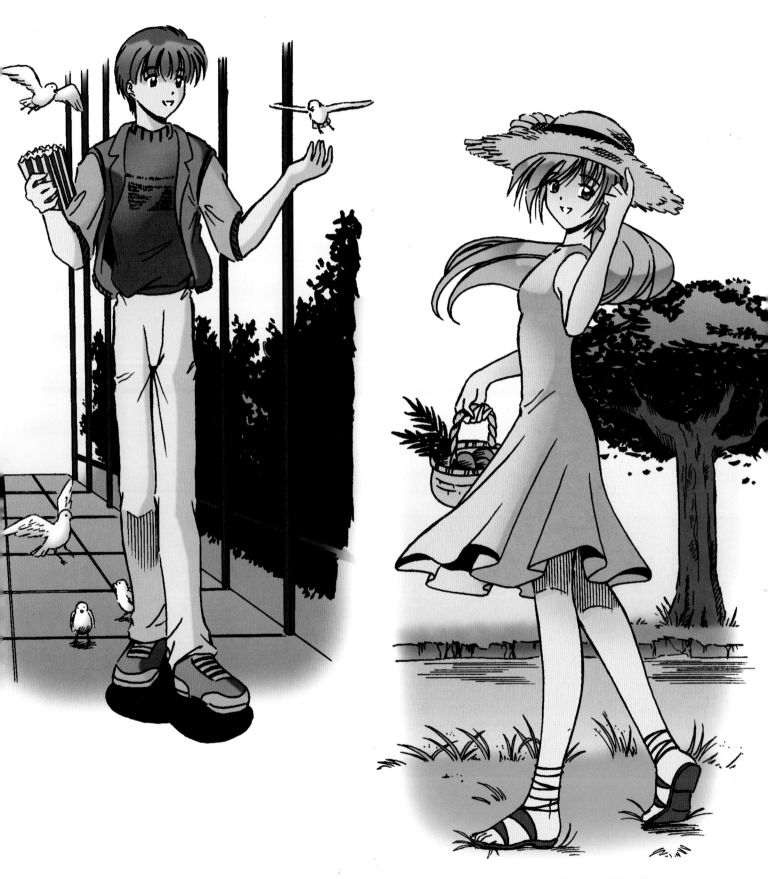

DRESS AND SANDALS

Furry Characters

These are hybrids—somewhere between human and animal. However, they exhibit very little remnants of animal anatomy. Their arms and legs are human, although they can have claws or paws. Sometimes, they have a furry texture to their skin. They can also have decorative markings, like leopard spots or tiger stripes. Their ears are always animal-derived, and they usually sport a tail. You can use a variety of ears here. Cat ears are most popular, but so are bear cub ears and lion ears. Combine these with different hairstyles to create a unique look. You can also draw the tail in different styles, for example a cat's tail or a long, thin cheetah tail.

Furry characters are pretty, cute, feminine, and very popular in the shoujo genre. Due to their unique appearance, they really stand out on the page. You can really enliven your stories by the addition of a furry character.

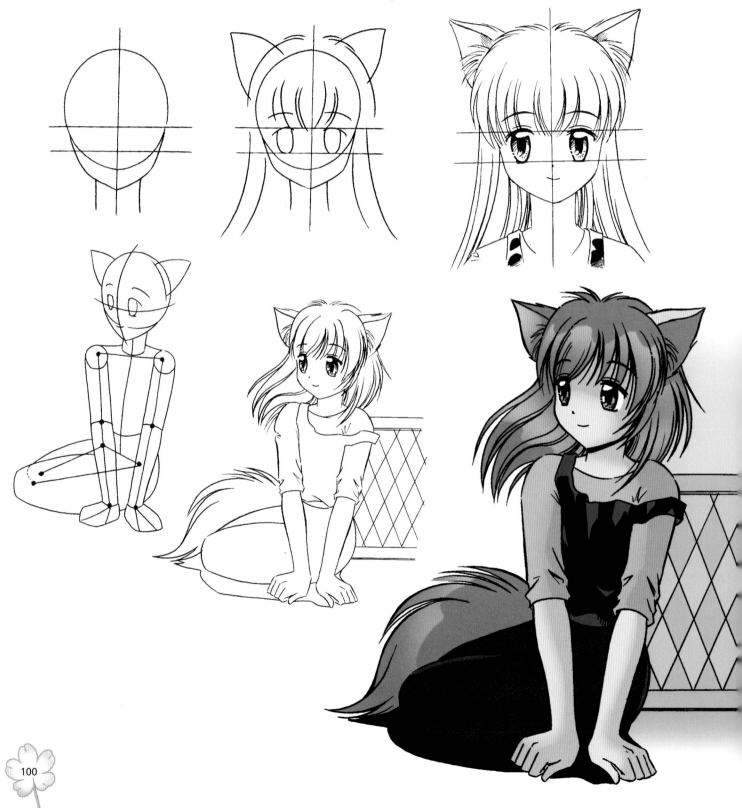

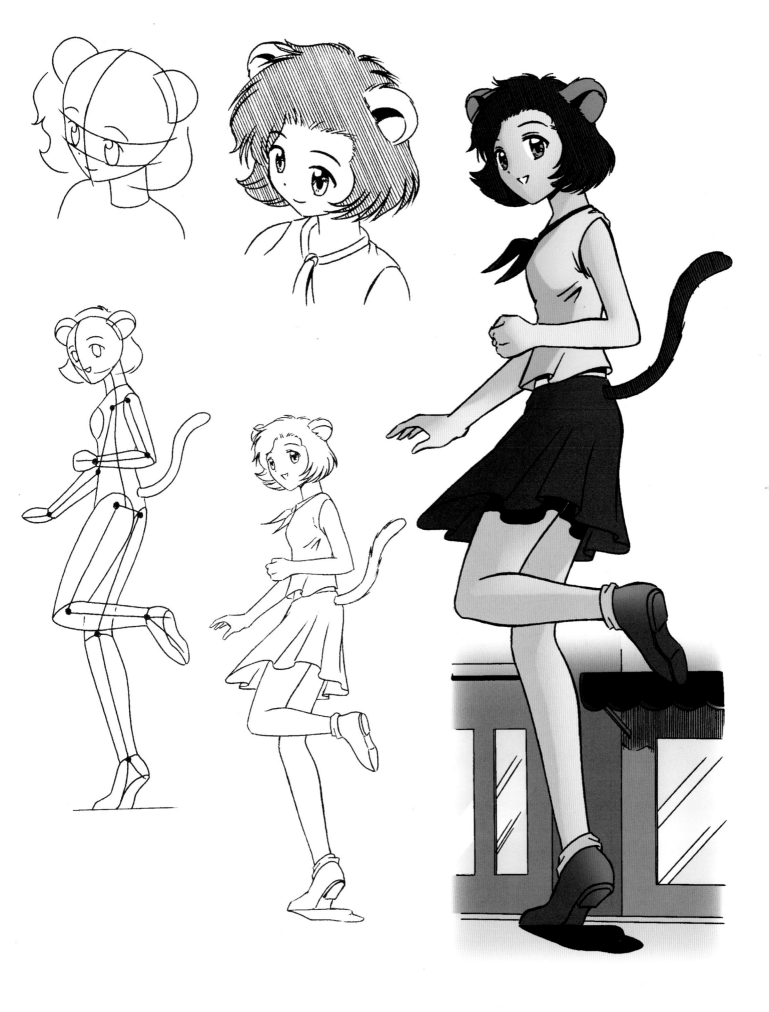

Drawing Chibis!

Chibi characters are a popular shoujo subgenre. Often overlooked by books about manga, chibis are never overlooked by manga fans.

Chibis are amazingly cute and funny. They're tiny people with big emotions. They aren't faeries or elves—nothing that small. They're like mini people, about 1/3 or 1/4 the normal size. however, there's more to drawing them than simply reducing their height. You have to adjust the proportions to increase the cuteness. You also need to exaggerate the features so that the characters look like more than just small-sized normal people. They're a style unto themselves. They're chibis!

NORMAL GIRL PROPORTIONS

A normal shoujo girl is 6 heads tall. Adult characters and older teens are 7 to 9 heads tall.

CHIBI PROPORTIONS

The chibi, by contrast, is only 2 heads tall—only 1/3 of the normal girl's height. The chibi girl's body is wider and more compact, with no waistline and thicker limbs. This gives her that squeezable cuteness.

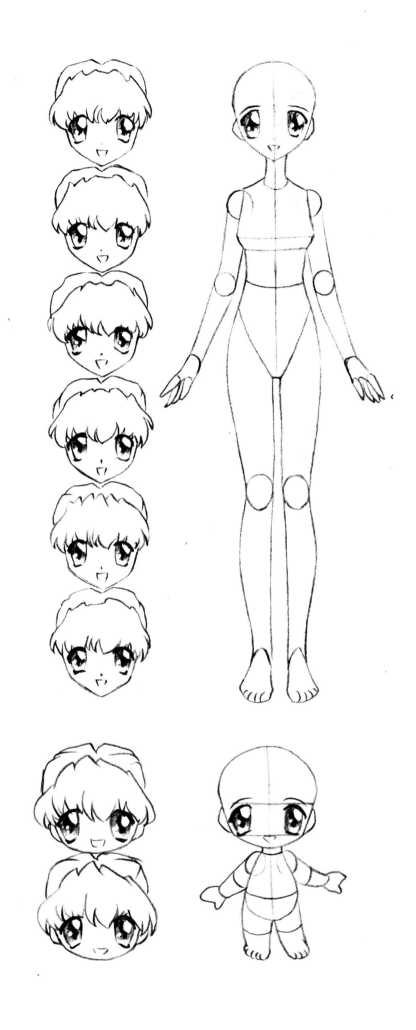

102

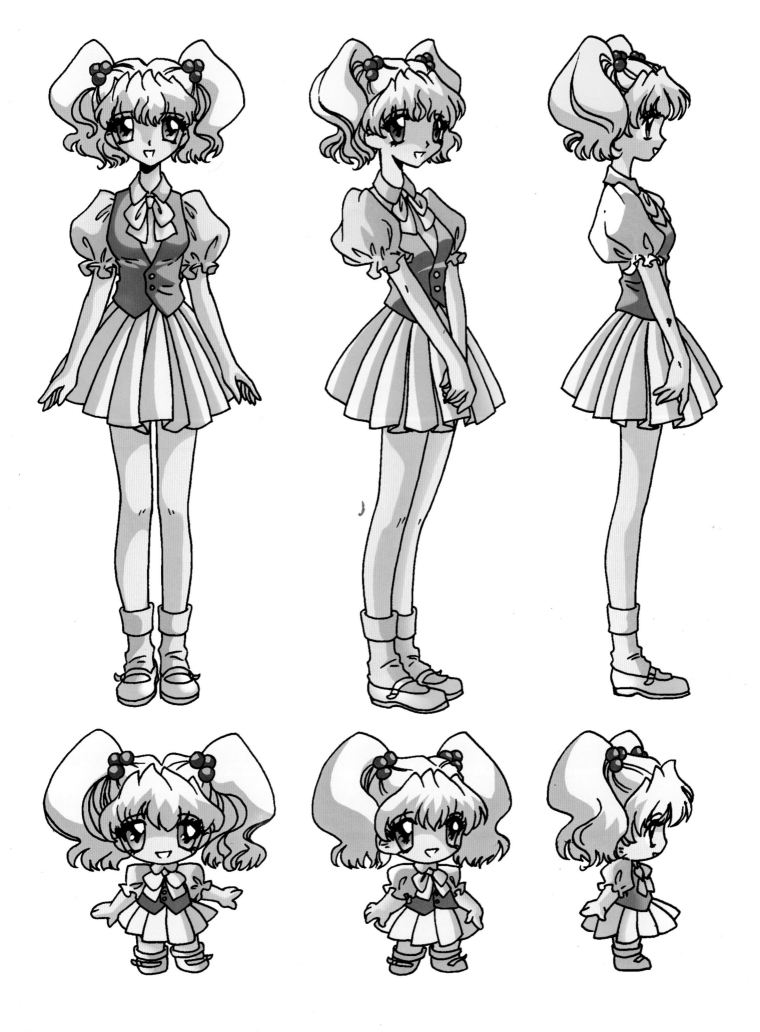

NORMAL BOY PROPORTIONS

The regular shoujo boy
is about 6½ heads tall.

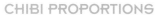

CHIBI PROPORTIONS

When you shrink him down
to chibi size, he's only 2 heads
tall, just like the girl chibi.

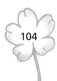

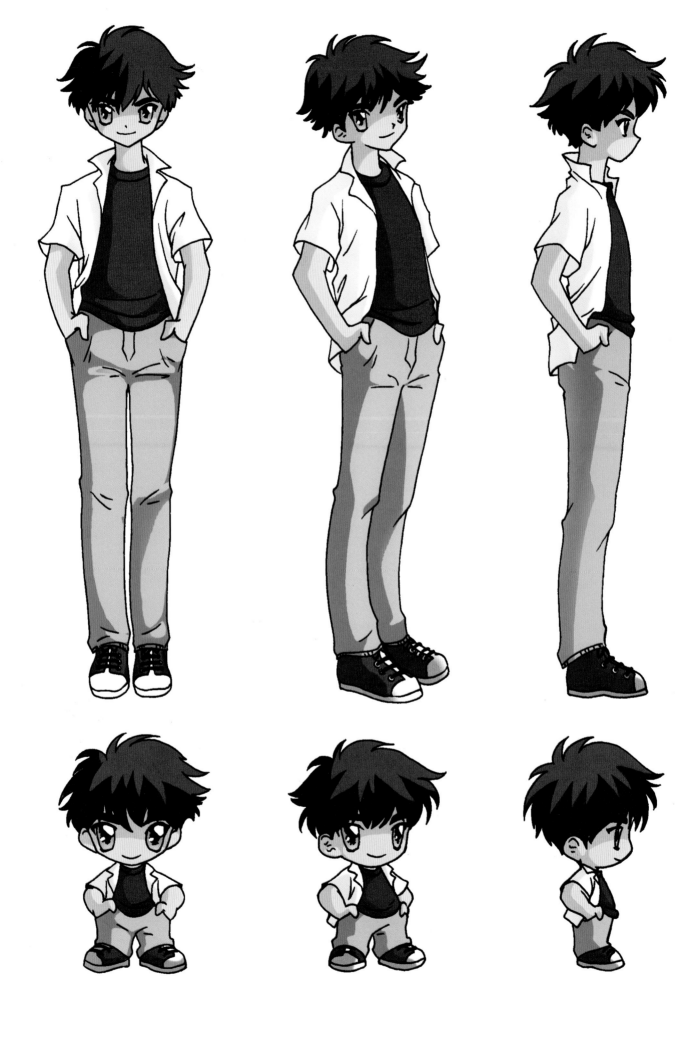

Heads and Bodies: Chibi Girls . . .

In the Middle Ages, artists painted babies with the same proportions as adults, only smaller. The results were weird: babies with adult bodies. You have to adjust the proportions of all the elements of a figure when drawing younger, tinier characters. This same rule also applies to chibis.

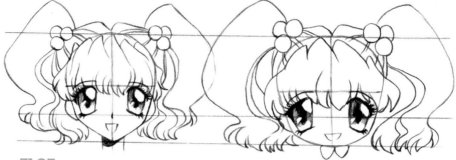

FACE

The chibi's face is wider than a normal face, and the eyes appear lower on the head. The eyes are bigger (wider), too, but the mouth and nose are not! Those must remain tiny. The forehead is wider and, therefore, covered with more bangs. Even the pigtails are fuller.

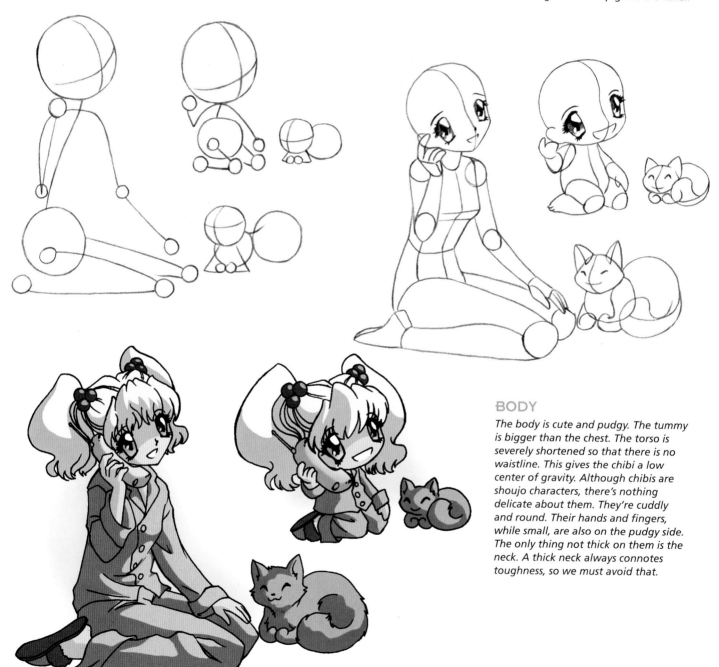

BODY

The body is cute and pudgy. The tummy is bigger than the chest. The torso is severely shortened so that there is no waistline. This gives the chibi a low center of gravity. Although chibis are shoujo characters, there's nothing delicate about them. They're cuddly and round. Their hands and fingers, while small, are also on the pudgy side. The only thing not thick on them is the neck. A thick neck always connotes toughness, so we must avoid that.

Chibis are based on toddlers (2-4 years old), except that the chibi head is vastly oversized in comparison to the body. This exaggeration heightens the adorable quality.

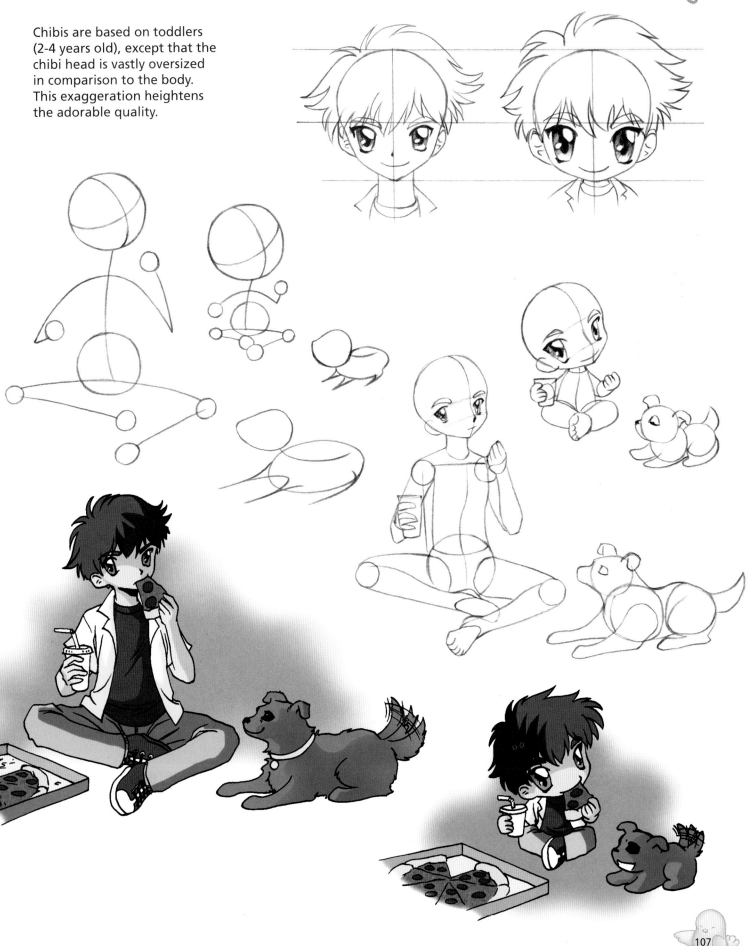

Small People with Big Emotions

Don't mistake chibis for timid, shy children because of their small size. Of course, they can be introverted, but when they feel an emotion, it's often a giant one. And they express it in a way that's larger than life. This brings us to the other side of chibis: Besides being cute, they're often quite funny and cast as humorous characters. The contrast of these tiny beings displaying huge emotions is quite comical. Compare what a normal emotion might look like to a true chibi emotion.

HAPPINESS

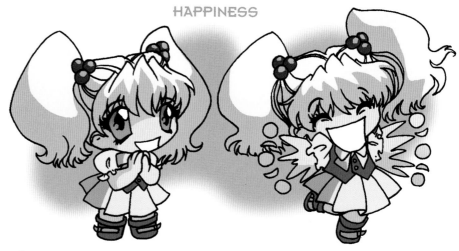

NORMAL

CHIBI

Flap the arms in excitement.

ANGRY

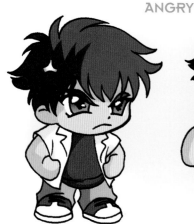

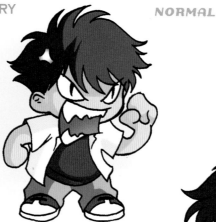

NORMAL

CHIBI

The mouth can extend beyond the face!

UPSET

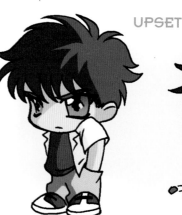
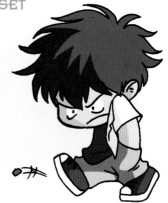

NORMAL

CHIBI

Stomp, stomp, stomp!

SAD

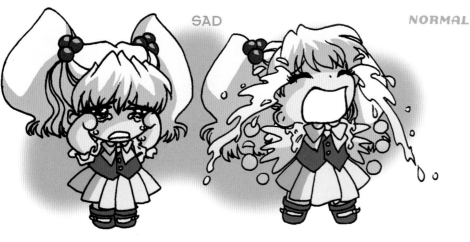

NORMAL

CHIBI

Buckets of tears.

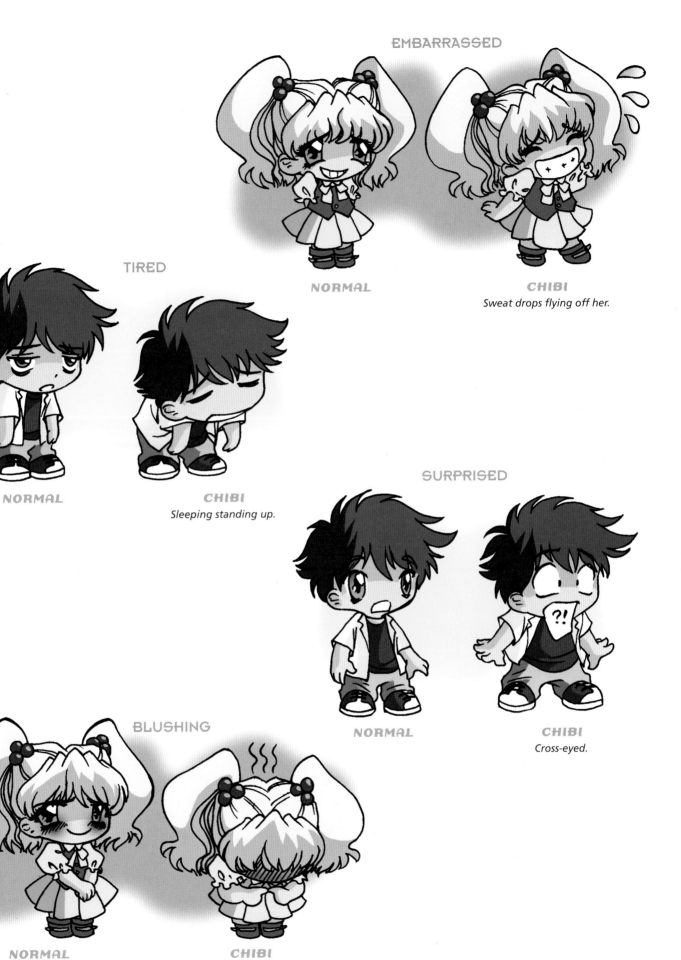

EMBARRASSED

NORMAL

CHIBI

Sweat drops flying off her.

TIRED

NORMAL

CHIBI

Sleeping standing up.

SURPRISED

NORMAL

CHIBI

Cross-eyed.

BLUSHING

NORMAL

CHIBI

Sizzle marks.

COOL CLOTHES

Since shoujo mostly features characters of similar ages (young teens), it's important to use clothing to make each character unique. Sometimes, clothing is underemphasized in books about drawing manga. However, well-drawn, authentic outfits make a character more believable. Think of the outfits in this section as your own Japanese clothing catalog that you can use whenever you need ideas for authentic Japanese clothing designs.

Clothing is basically drapery that has been hung on a person instead of on a window. Just as drapes have folds and creases, so do clothes. The body under the fabric causes many folds, creases, and wrinkles to appear. Let's look at the dynamics involved.

SKIRTS

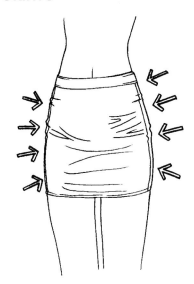

The mini skirt hugs the hips, creating horizontal folds.

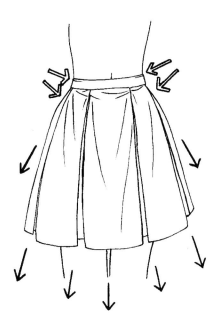

The waistband of the pleated skirt holds up the weight of the skirt, resulting in some small horizontal folds. The pleats hang straight down with a few short vertical folds.

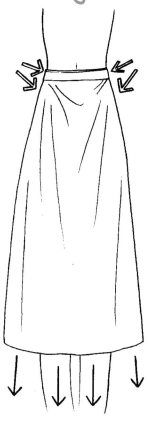

As with the pleated skirt, the waistband of the long pencil skirt supports the weight of the skirt, creating a few small creases at the top. Since there are no pleats, longer vertical folds appear down the length of the dress.

SITTING

When a woman sits, the pressure of the fabric creases travels horizontally across the top of the skirt. Where the knees bend, the dress drapes downward, pulled by gravity. That's where the folds become vertical again.

WINDBLOWN

Here, the wind pushes the skirt against one side of the figure and causes it to billow on the other side. So, folds travel from the upper right of the drawing diagonally across to the lower left.

WINDBLOWN— PLEATED

The wind has the same effect as with the plain skirt, however, you must retain the pleats

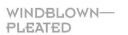

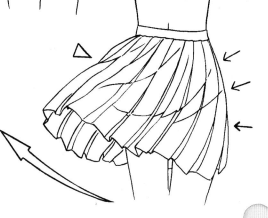

Basic Shapes for Boys' Clothes

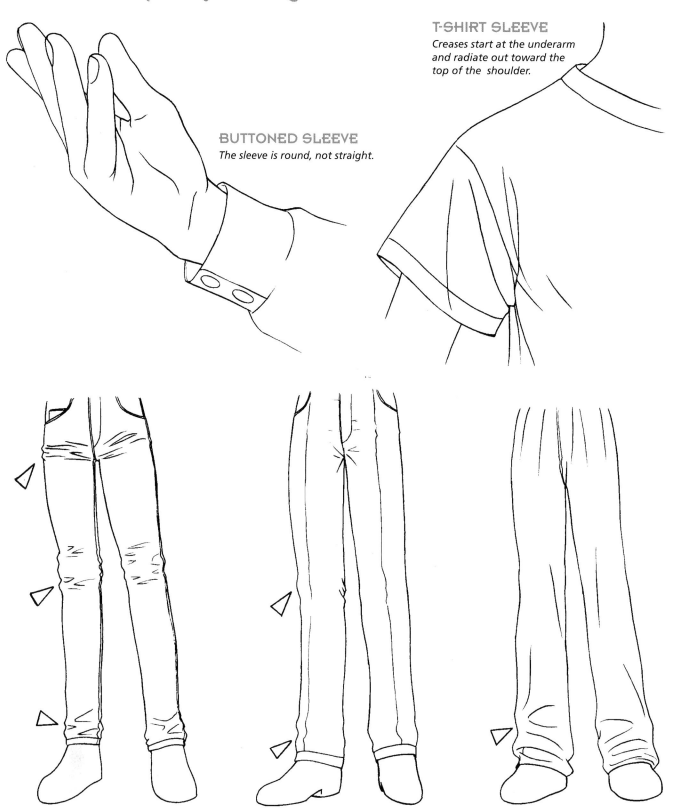

T-SHIRT SLEEVE
Creases start at the underarm and radiate out toward the top of the shoulder.

BUTTONED SLEEVE
The sleeve is round, not straight.

JEANS
Horizontal gathers or folds occur at the tops of the thighs, the knees, and the ankles.

SLIM-FITTING KHAKIS
With softer material, such as khaki or chino fabric, small folds occur at the crotch, the knees, and the ankles. They are much less pronounced than the folds on jeans.

LOOSE-FITTING KHAKIS
Since these pants are baggier, the fabric hangs more, so the folds at the top and the knees are vertical, and there are more horizontal folds around the ankles where the looser fabric bunches.

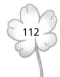

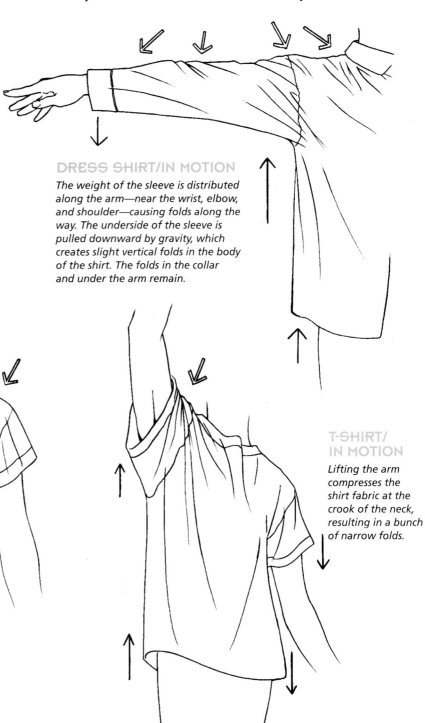

STRESS POINTS

Clothes are meant to hang off the body. As they hang, gravity pulls them down, causing creases and folds. There are certain stress points on the body that bear more of the fabric's weight; this is where most of the folds will occur. When the body moves, those stress points can change, and therefore, the folds will have to be adjusted. Take a look at some of the dynamics involved.

DRESS SHIRT/ RELAXED POSE

In the relaxed pose, most of the creases occur at the neck/collar and underarm areas of the garment.

DRESS SHIRT/IN MOTION

The weight of the sleeve is distributed along the arm—near the wrist, elbow, and shoulder—causing folds along the way. The underside of the sleeve is pulled downward by gravity, which creates slight vertical folds in the body of the shirt. The folds in the collar and under the arm remain.

T-SHIRT/ IN MOTION

Lifting the arm compresses the shirt fabric at the crook of the neck, resulting in a bunch of narrow folds.

T-SHIRT/RELAXED POSE

The collar and underarms bear most of the weight and compression of the fabric, so that's where most of the folds are located.

School Uniforms (Again!)

Hey, they're megapopular in Japan and in the anime shown on American television. So, here are a few more styles.

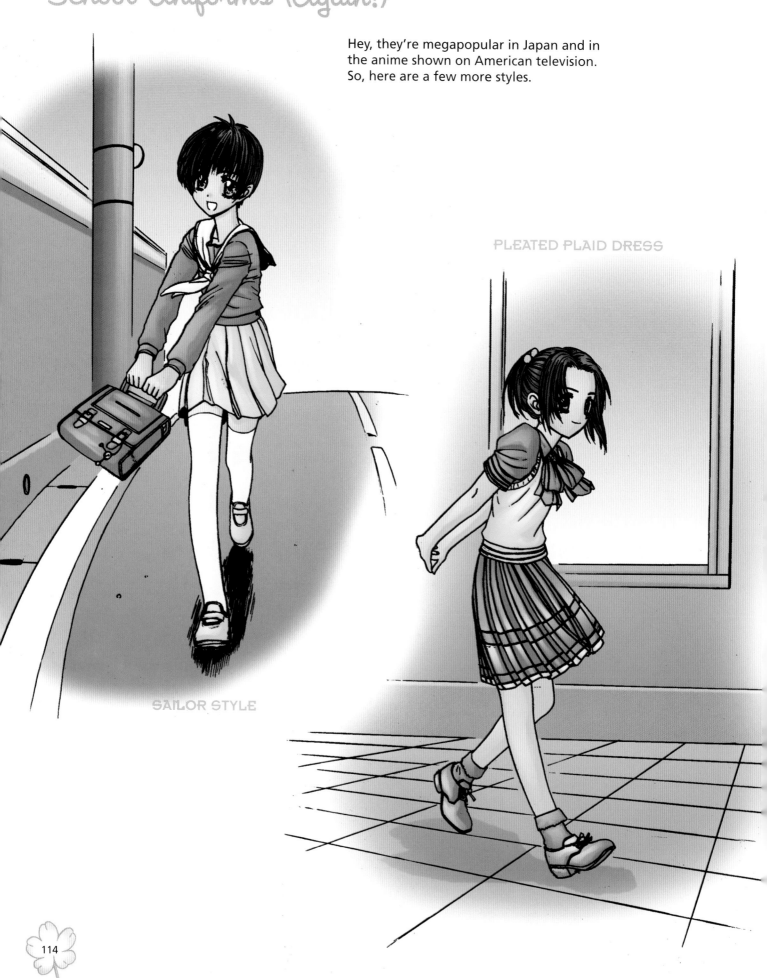

PLEATED PLAID DRESS

SAILOR STYLE

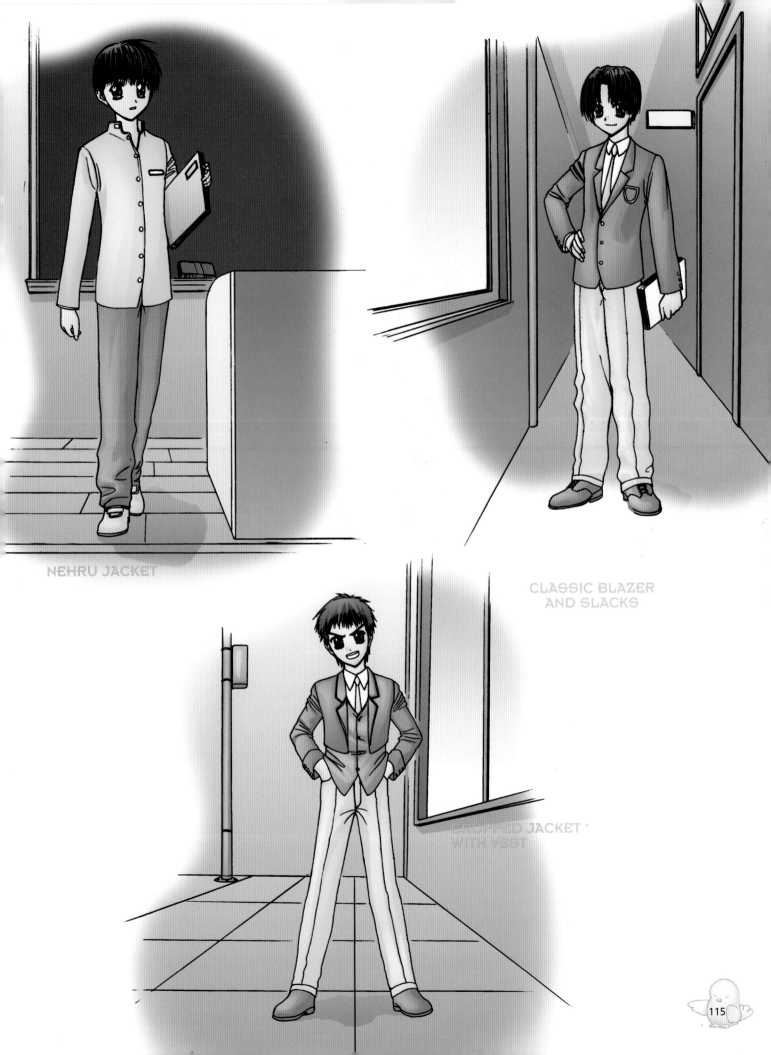

NEHRU JACKET

CLASSIC BLAZER
AND SLACKS

CROPPED JACKET
WITH VEST

115

Casual Wear

In Japan, American styles are considered cool. Whenever a new style develops in America, it won't be long before you begin to see it in Japan, where it is reflected in the comics.

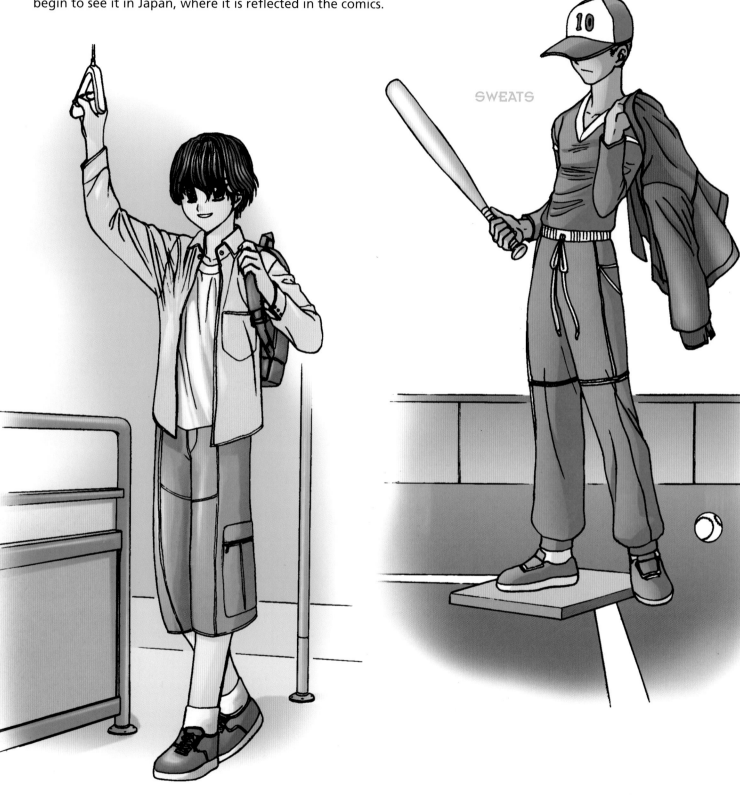

SWEATS

LONG CARGO SHORTS

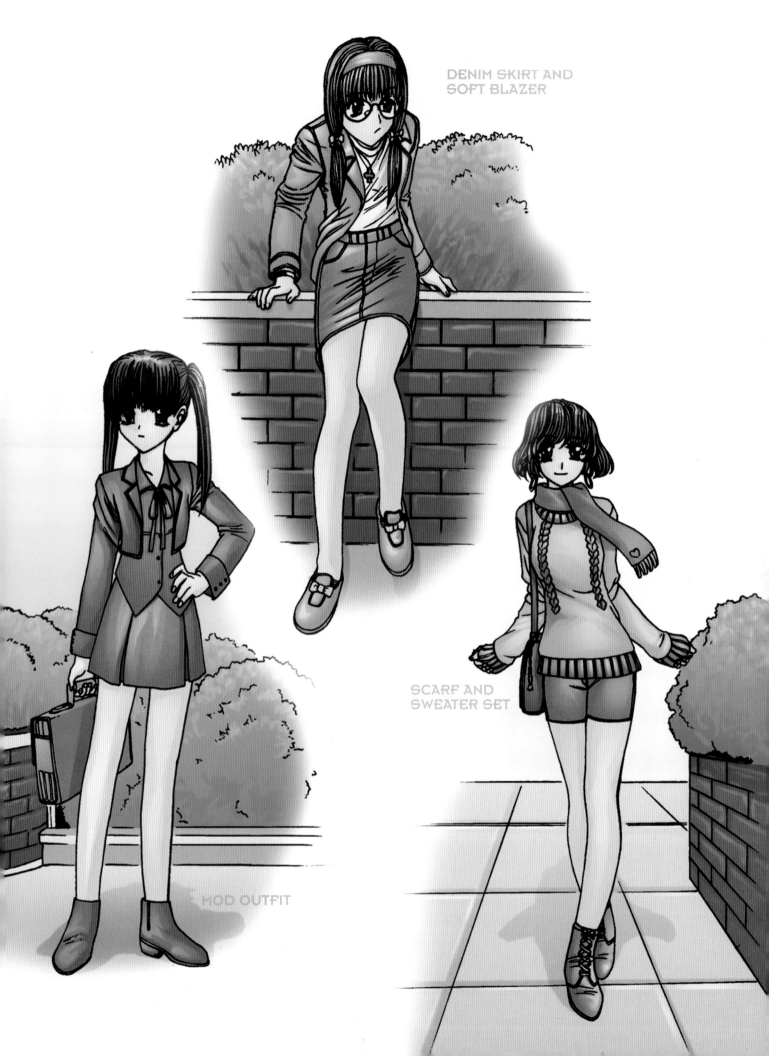

DENIM SKIRT AND
SOFT BLAZER

SCARF AND
SWEATER SET

MOD OUTFIT

More Casual Wear

Don't forget about the seasons; clothing styles change when the weather gets cooler. Layers and hats are worn.

SHORTS AND SWEATSHIRT

HOODED TOGGLE-BUTTON COAT

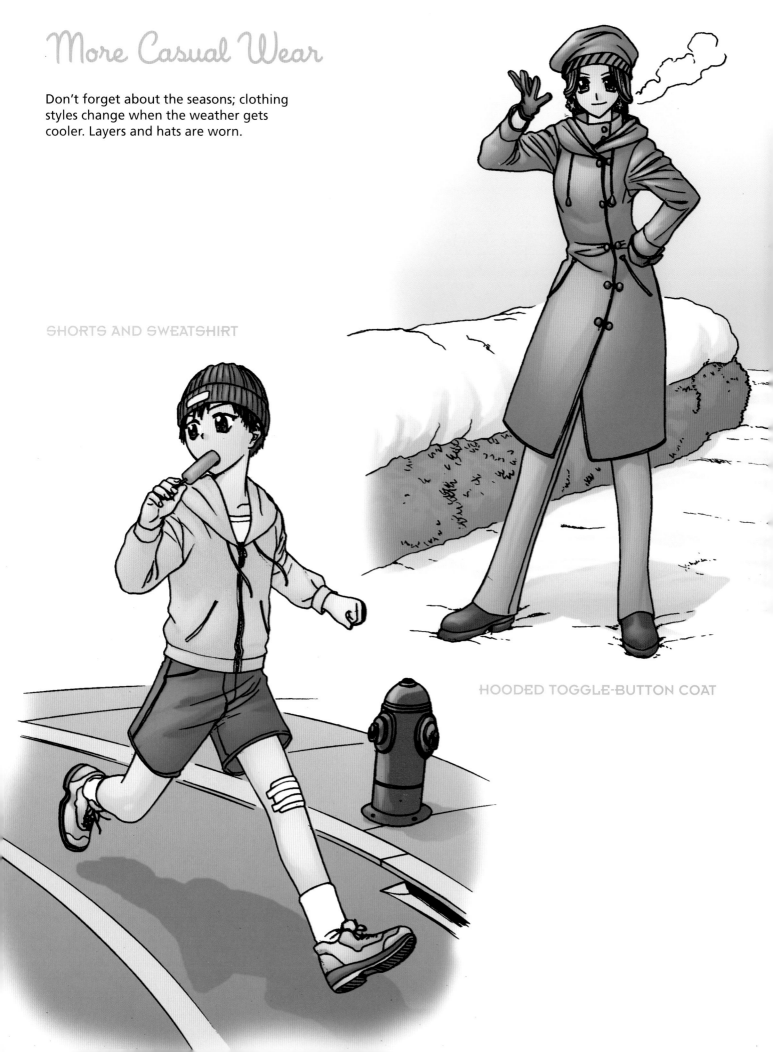

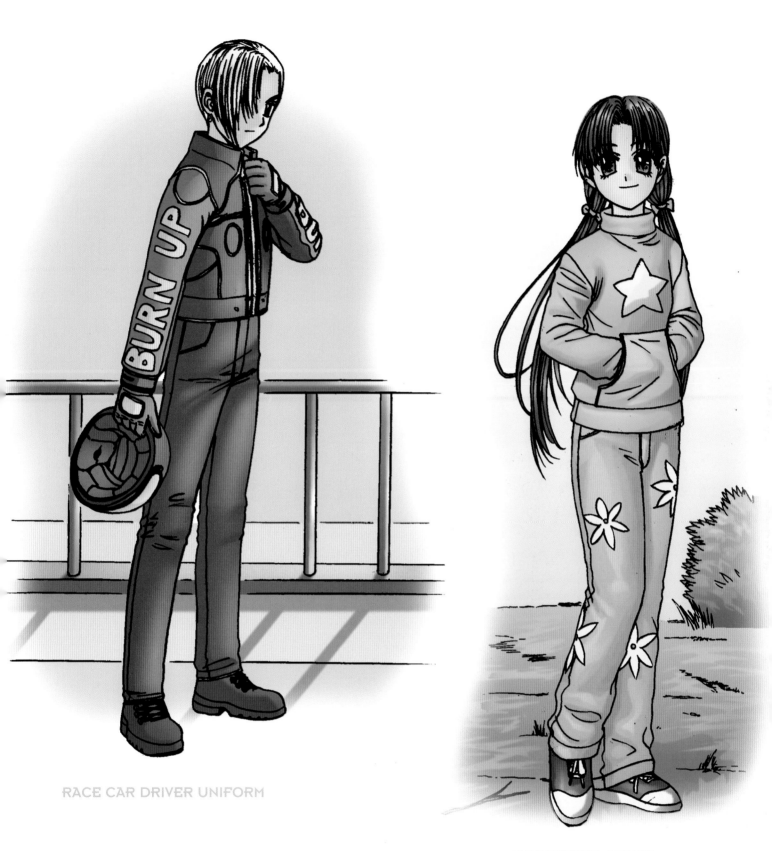

RACE CAR DRIVER UNIFORM

DECORATED JEANS

Summer Clothes

Playful outfits are a part of every kid's wardrobe. This is the stuff kids can get dirty without their parents minding.

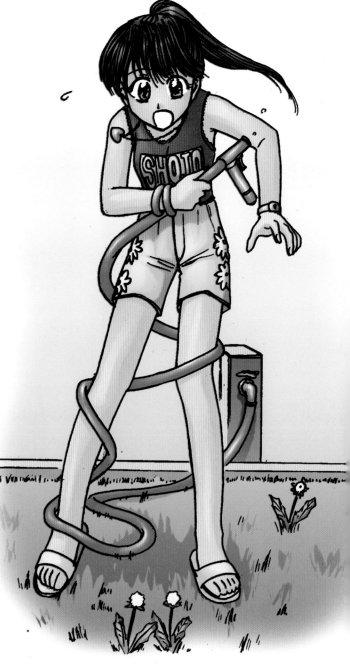

SHORT OVERALLS

OVERALLS

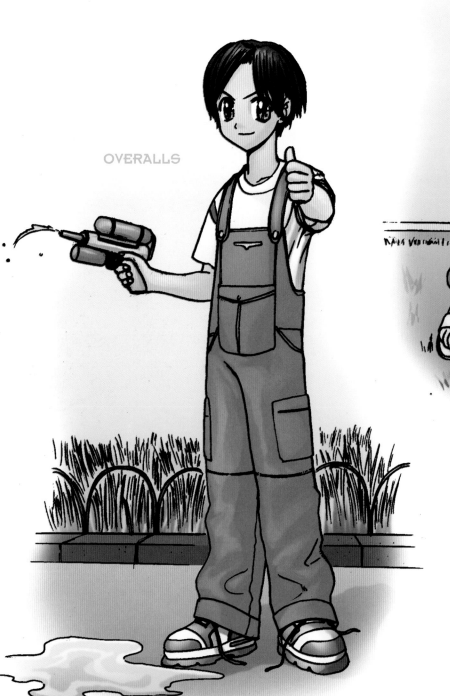

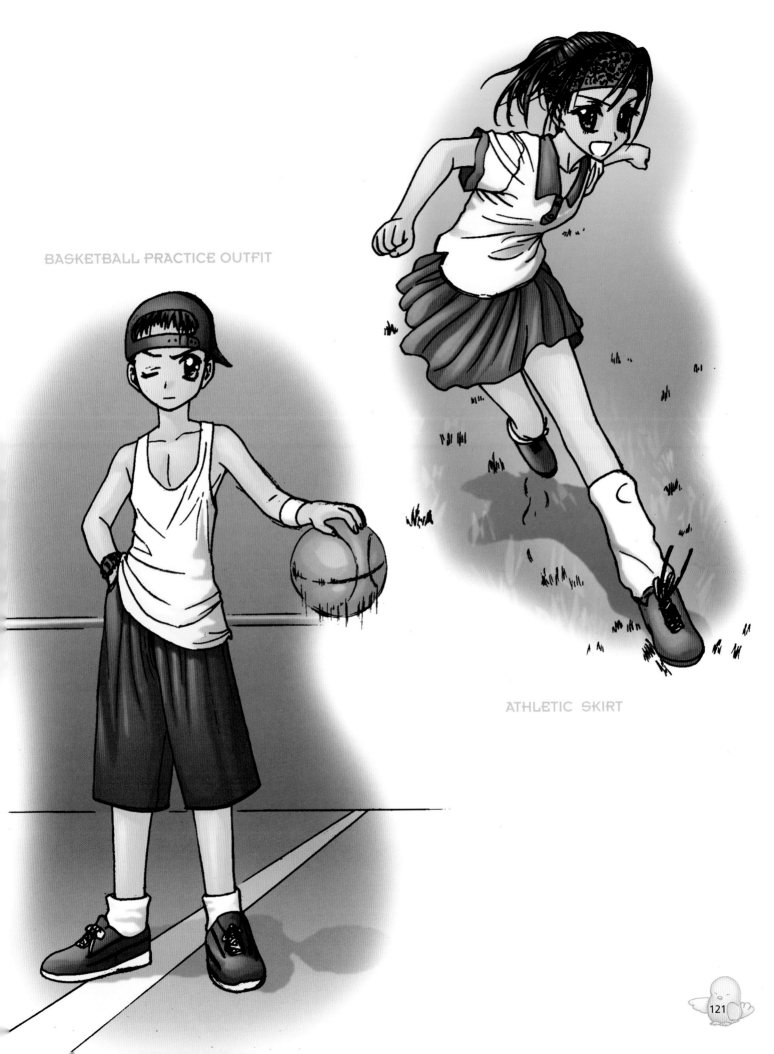

BASKETBALL PRACTICE OUTFIT

ATHLETIC SKIRT

Extreme Outfits

One of the things that distinguishes kids and their clothes from adults and theirs is that kids like clothes with printing or designs on them. Here the clothes are as loud as a set of huge speakers, just the way he likes them.

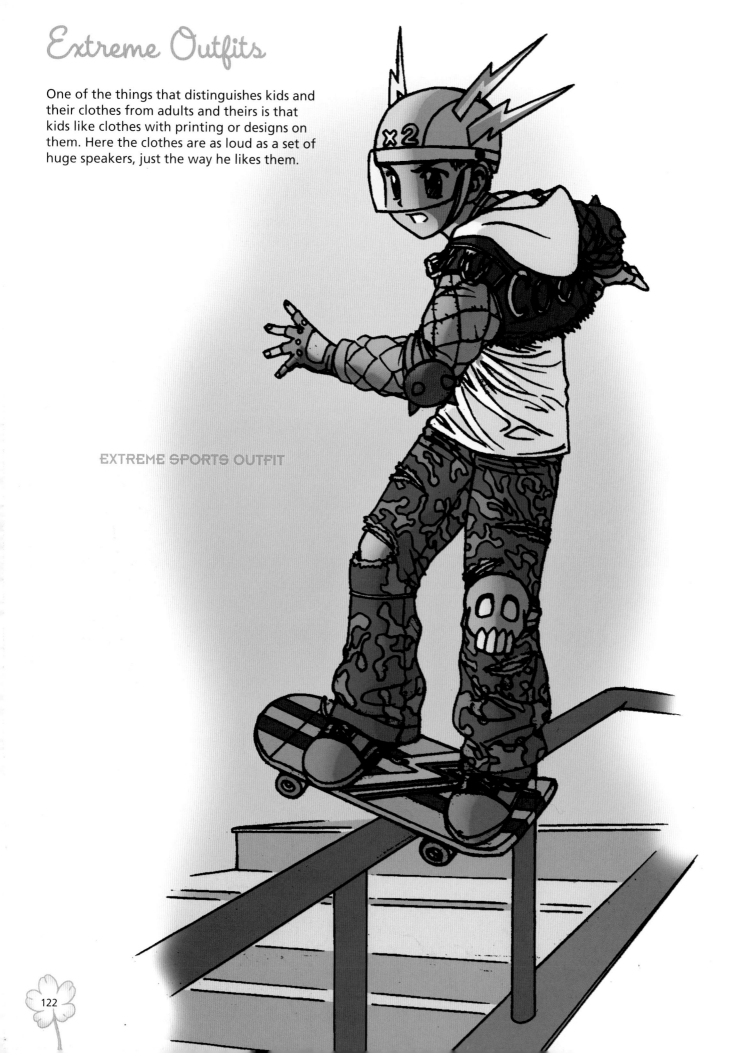

EXTREME SPORTS OUTFIT

POP STAR WANNABE

Design Details

As an artist, sometimes you have something to say that can't be conveyed by pose alone. You need to add text and color. But, how do you add speech balloons and color so that they don't take away from the illustrations? That's the focus of this chapter.

Correct Speech Balloon Location

Although speech balloons look pretty straightforward and simple to use, nothing can so quickly brand your work as amateurish as the incorrect use of a speech balloon. When aspiring artists show me their work, my eye is first drawn to the speech balloons, because a poorly placed speech balloon can make a fine drawing look bad. This section will help you avoid the pitfalls you might otherwise encounter with your speech balloons. Don't fumble the ball at the two-yard line—take a moment to review this information.

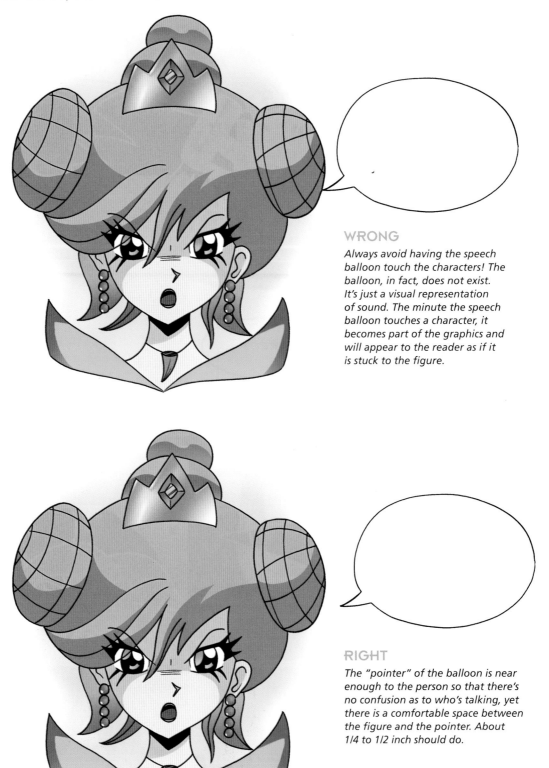

WRONG

Always avoid having the speech balloon touch the characters! The balloon, in fact, does not exist. It's just a visual representation of sound. The minute the speech balloon touches a character, it becomes part of the graphics and will appear to the reader as if it is stuck to the figure.

RIGHT

The "pointer" of the balloon is near enough to the person so that there's no confusion as to who's talking, yet there is a comfortable space between the figure and the pointer. About 1/4 to 1/2 inch should do.

Coloring Your Comics

There's no doubt about it—color makes your drawings really pop. Color can turn a good drawing into an awesome one. But, color alone won't do the trick. It has to be used intelligently.

There are specific color palettes used to create the shoujo look. The use of contrasting (light and dark) colors, color combinations, and cool colors versus warm colors are just a few of the techniques that allow comic book colorists to create spectacular effects.

Most graphic artists scan their drawings into the computer, and then use a variety of programs to add color to them. The most widely used program by professional artists is Adobe Photoshop. But since programs change and are upgraded, I'm going to give you the general principles of comic book computer coloring, rather than review the functions of each specific program command. These indispensable principles are transferable to all computer programs, as well as to freehand coloring with such mediums as markers, watercolors, and colored pencils.

It all begins with the black-and-white line art (the drawing done by hand). The colorist scans this into the computer, using Photoshop or another software program. Since the artwork is ultimately going to be printed, the colorist selects a resolution of 300 dpi (dots per inch). Each dot is a tiny piece of the image. (It's like a photo in a newspaper; if you look at it with a magnifying glass, you can see that it's made up of hundreds of tiny dots.) The more dots there are, the finer and higher in quality the image will be. The best reproduction for color comics and images in other printed materials is 300 dpi.

Using the computer program, the colorist then separates the image into sections, for example the head, eyes, hair, shirt, earrings, and so on. This enables each section to be colored separately so that any section of the drawing can be changed without recoloring the whole image. This is a great advantage over handcoloring.

For shoujo, work from a bright, pastel palette. Shoujo gives artists the freedom to color the hair and eyes with unusual colors (also from this same bright palette.) This makes the characters pop from the page.

Here, examples of four different palettes are shown. These different color combos might be shown to the editor for input or approval, and the character's color scheme can then be locked down at that point.

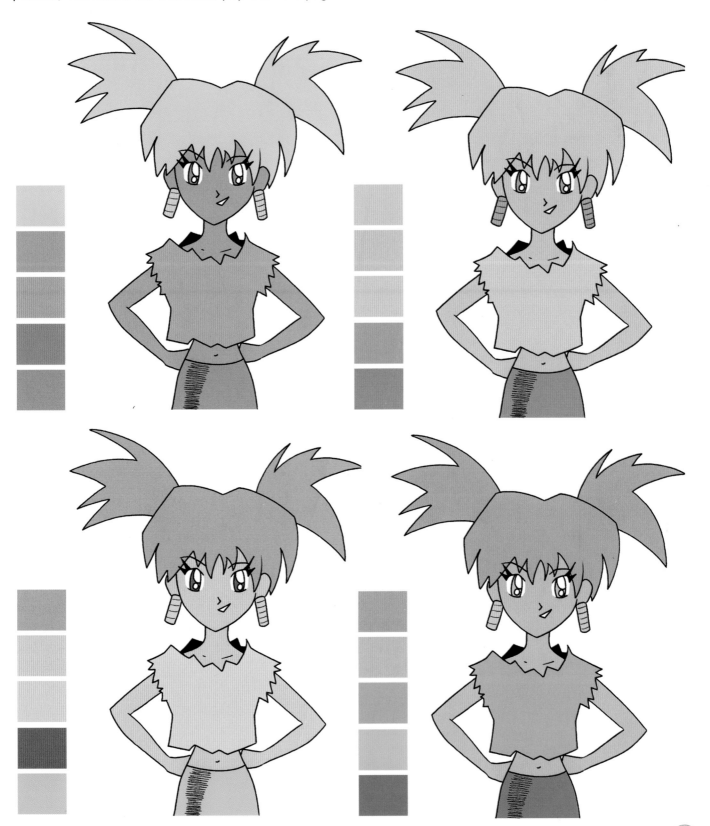

131

Flat vs. Shadows

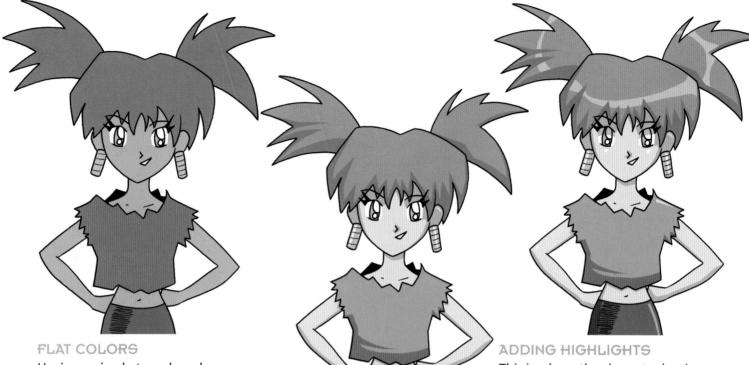

FLAT COLORS

Having arrived at a color scheme, all the flat colors are applied first. The term *flat colors* refers to colors added with no shading that would create a more dimensional look. The pastel palette is still used, but the colors are a little stronger and bolder so that the character doesn't get washed out. Shoujo characters may call for a soft, sweet look, but too soft a look makes the colors appear bathed in milk. It gets too frothy and white, and drains the character of impact. Even pretty characters need to pop off the page. You can't afford to substitute impact for sweetness. It'll cost you readers. This color scheme has it all.

ADDING COLOR SHADOWS

There's always a light source, and where there's a light source, there are shadows cast by that light. Usually, the light source is overhead in the form of sunlight or interior ceiling lights. The light hits the figure and immediately casts subtle shadows. These are essential, as they give the illusion that the figure is 3-dimensional and real. There's also the stylistic reason to include shadows: Crisp, clean (not gradated), color shadows are a trademark of Japanese comics.

As the light hits the top of the character's head, the shadows form on the underside of the hair and on the part of the face hidden beneath the bangs. The neck gets a cast shadow under the chin, as do the undersides of the arms, which are facing away from the overhead light source. The bottom half of the shirt also gets hit with shadow, being furthest from the light.

Notice how much more three-dimensional this figure looks than the one at left, all due to the use of a few simple shadows.

ADDING HIGHLIGHTS

This is where the character begins to sparkle—to offset the shadows, highlights are added. Highlighting is more of an art than a science. It's an "emotional" application. In other words, rather than being a literal representation of light on an object, it is a creative choice—based on what looks good to the artist.

In shoujo, as in most manga, the crown of the head gets a large streak of highlights. This streak must be curved to reflect the roundness of the head. The pigtails don't require highlights, but the colorist chose to highlight here anyway. It's a pleasing effect; the highlights on the pigtails become a continuation of the highlights on the crown of the head. Her right shoulder and the right side of her skirt also get highlights so that the brightness of the head doesn't overwhelm the body. And, the earrings get highlights because they're gold and, therefore, reflective.

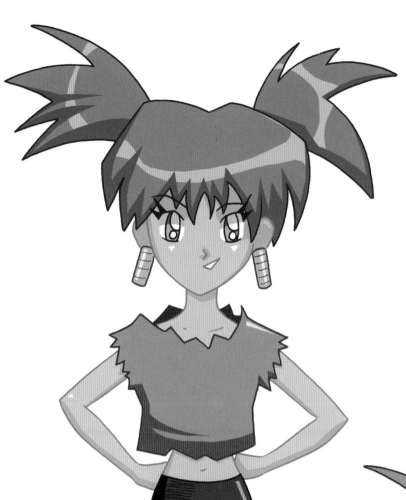

WARM VS. COOL COLORS

Color is often described in terms of temperature. Warm colors—reds, oranges, and yellows—are associated with sunlight, and are energizing and exciting. Cool colors—blues, greens, and violets—are associated with water and shadows, and are calming and soothing.

To create a more exciting character, try shifting over to a palette that has more warm colors. Hot pink is a good shoujo color, because it's young and feminine but also has an electric quality.

Note: Here, the pink hair is outlined with a purple, because purple provides a nice contrast to the pink. Plus, a pink outline would get lost against the color of the girl's face.

USING COLOR HOLDS

Can you tell the difference between this image and the one on the opposite page? It's a finishing touch that often goes unnoticed but, nonetheless, makes an important subconscious impression on readers. There are no black holding lines here. All the outlines have been changed to color—and not just one color but many different colors! These are color holds. Since the hair is purple, the outline of the hair is a darker purple. Since the shirt is orange, the outline for it is a darker orange, and so forth. This is the traditional method for changing black outlines into colored ones.

Before this change, it looked like color was just filled in. But once the outline itself is in color, the image looks even more vibrant, and the color no longer looks like an afterthought.

Note that shadows have been added under the eyelids (and falling onto the eyes), which gives the eyes more depth.

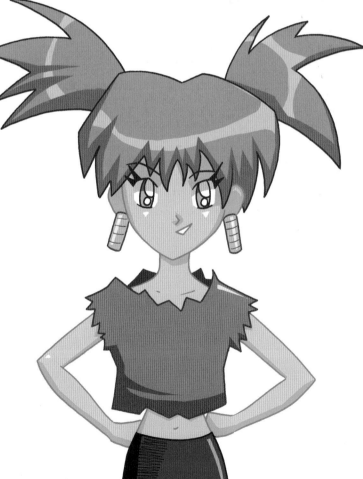

From Black and White to Color

The series of illustrations over the next few pages shows the progression of an image from uncolored to colored. Let's take a look.

LINE ART

This is the basic black-and-white line art that's scanned into the computer. As the colorist, you would examine the scene and ask yourself some questions about the terrain and the environment before you begin: Is the ground rocky or grassy? Or, is it just dirt? Perhaps it's sandy. Maybe you can give it texture to look like pebbles. Would that draw too much attention to it, or would it look cool?

There are many areas of the picture to consider, each separately from the other. You'll want to create some depth with those bushes in the foreground. In the background, the palm trees create a pleasing, repeated design against the mountain range. In fact, the entire image looks very junglelike, very green and lush. So, that's the theme to go with.

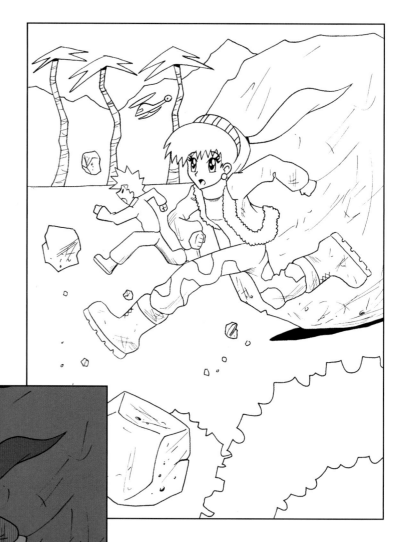

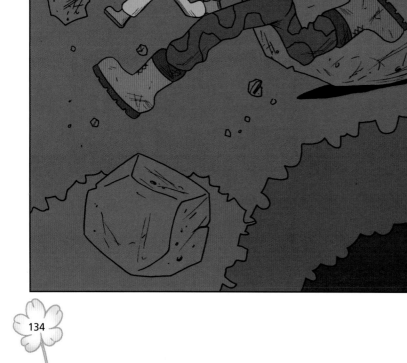

FLAT COLORS

Adding the flat colors is only the beginning, like making an initial sketch. You can do some experimenting with the colors now.

134

MAIN CHARACTER COLOR VARIATIONS

The girl is the main focus of the scene, so vibrant colors are a good choice to draw attention to her and away from the background. You can play around with different combinations before settling on a final version. The various hair colors run the spectrum from realistic to totally outrageous, but in shoujo, it all works. She's wearing a camouflage outfit, but if she blends in too well to the environment, she won't make an impact on the reader; keeping her pants toned down but brightening her bomber jacket avoids this problem. The black holding outlines have been left in place. They lose some of the colorful quality they would otherwise gain from color holds, but the black lines help make the figure pop against the background.

BACKGROUND ELEMENT VARIATIONS

Sometimes, the process is trial and error, or as it's often described, "Throw a few ideas against a wall and see which one sticks." This is a visual art; you can't always conceptualize colors in your mind. Sometimes, you have to put them out there in front of you to see. These variations play with the green of the palm leaves and the tan of the bark. Should the bark have more yellow in it or more red? Should the palm leaves have more yellow-green or more bluish-green?

COLOR HOLDS

Black lines define space more clearly than colored lines. Since this scene has so much action, it's important that it reads clearly right away or it might get confusing. To that end, the colorist uses color holds on the helicopter, turning its black outline into a color outline and thereby softening the image so that it doesn't stand out.

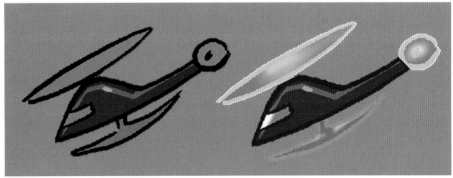

INDICATING DISTANCE WITH COLOR

How do you indicate that things, like the mountains here, are off in the distance? You make them lighter and hazier, not darker as you might think. Things in the distance get hazy, because the light diffuses their color. The more distant the object, the lighter it is. Therefore the mountains have been colored with a medium gray and a second tone of light gray. There's a gradient haze at the base of the mountain (an airbrush-type effect) to show that it is far back.

The sky is also light and simple, so as to recede into the background, rather than being a bold blue, which would pop. The bushes in the foreground are closer to the reader, however, so they require more detail, like individual leaves. Also, giant shadow under the main boulder adds weight to the object as it is about to pancake that poor girl!

Despite all this, the colors are still blending too much, and the picture looks a bit muddy. It still needs one more revision.

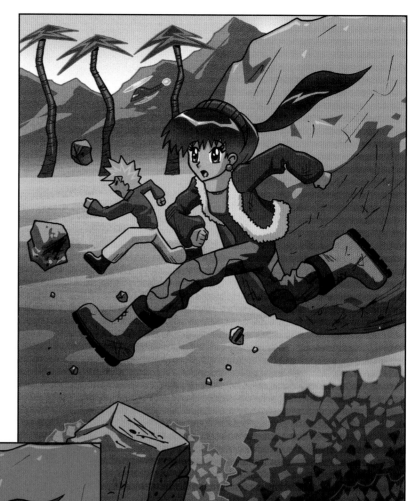

GETTING THE RIGHT COLOR CONTRAST

For the final version, more contrast is added. Lighter areas are juxtaposed against darker ones. There was too much green throughout the picture before. Now the green is sprinkled throughout but does not dominate. It's a clear, colorful action scene that works.

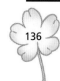

Although more manga is now being done in color, most of it is still reproduced in black and white. So it's good to develop the skill of using gray tones to "color" your drawings. Everything boils down to contrast.

Let's look at the elements of this image. There's a giant sun beating down on a plane crash survivor. The desert is hot and barren. The key to this picture is contrast: Blazing, white-hot areas contrasted with shadow. There are 4 major tones at work here: the black of the smoke and the survivor, the gray of the sky, the lighter gray of the sand, and the hot white of the sun. Each contrasts nicely with different-strength tones.

A rule of thumb is the harsher the light, the starker the shadows. Also, you cannot have a white sun against a white sky. The sun would disappear, and the sun is the antagonist in this scene. So, you must darken the sky enough so that the white ball of fire in the sky really sticks out.

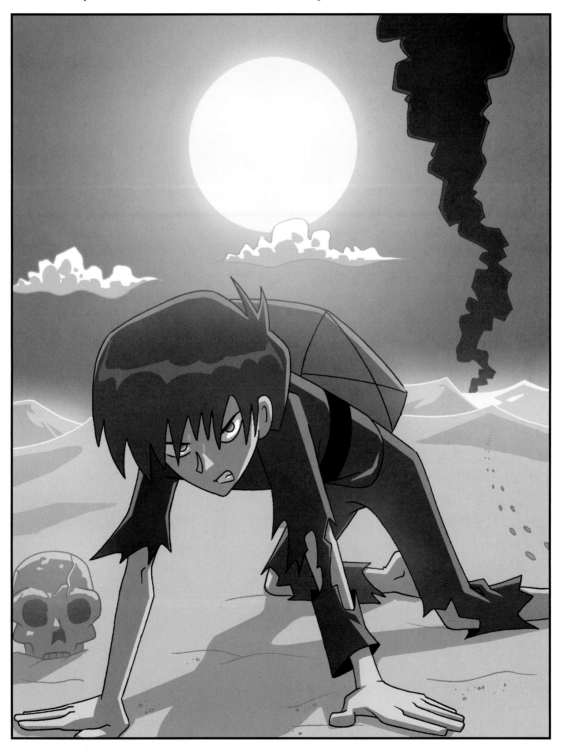

FLAT COLORS

If you were to add color, it might look something like this. Some scenes are easier to color than others. These colors are basically decided by the objects they're depicting. There's a little bit of a red tint in the sand to give it more emphasis, and some red in the smoke to remind the reader of the crashed plane on fire.

GLOWS

Glows are great for many things, from magical special effects to gunfire bursts. Here, a huge, dissipating glow creates an agonizingly hot sun. Note the addition of shadows to the underside of the cloud; it's a nice— and necessary—effect.

FLAT COLORS

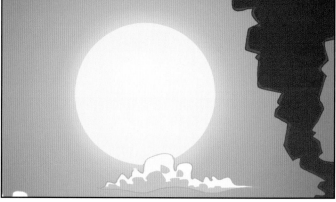

GLOW

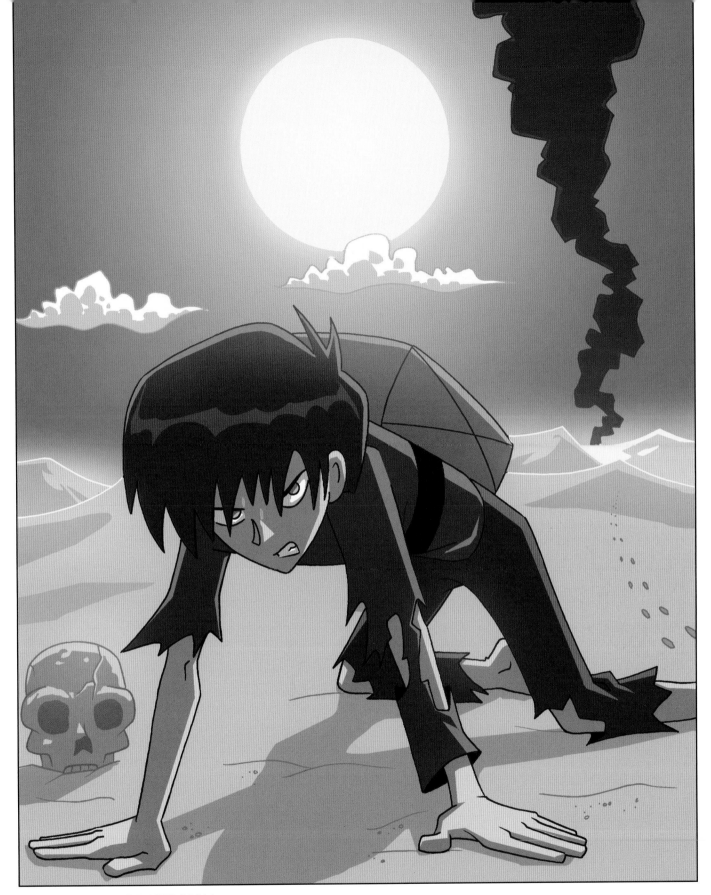

FINISHED COLOR VERSION

Here's the completed color version, with shadows, highlights, and glows. The sun, clouds, skull, and dunes have color holds, whereas the kid does not. This is because he is given a very harsh treatment, and color holds tend to soften the look of a character. Note the edge-lighting highlights all over him showing the intensity of the sunlight.

Playing with Color

Every once in a while, you get a really cool scene that could go in two totally different directions. That's the fun of being a computer colorist: Your interpretation of the scene not only enhances it, but sometimes changes it into something totally unexpected.

FLAT COLORS

With a cobalt blue sky, this image makes a nice daytime scene. It has lots of layers: kids, buildings, clouds, and planets.

LINE DRAWING

This is the original black-and-white line drawing.

SHADING AND HIGHLIGHTS

These colors offer a bright, cheerful vision of the future. Shading and highlights are necessary so that all the elements in the image don't flatten out and rob the picture of a feeling of depth. The kids are flying toward the reader, which means that they have to appear to come forward while the background must appear to recede.

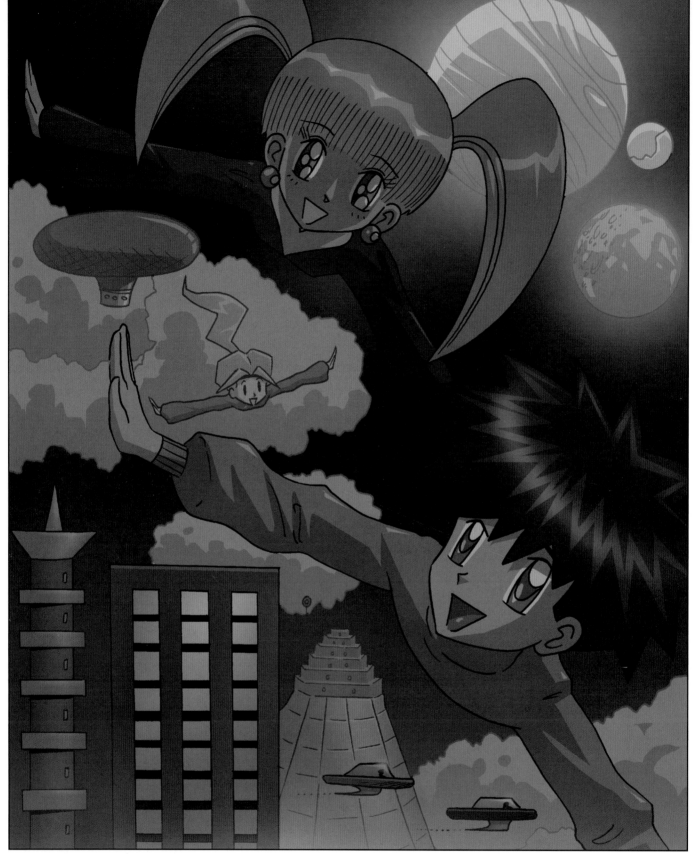

CHANGING DAY INTO NIGHT

With so much sky in the picture, you have a great opportunity to make a nighttime scene without a single pen stroke being changed. It's all in the colors! A blue tinge is added to everything; this comes from the planets and moons, which now serve as subtle light sources.

But wait, something seems to have been lost here. The scene feels a little bleak and dark—not cheerful and fanciful as it was before. Does that mean that it shouldn't be a nighttime scene? Not necessarily. . . .

Let's tweak it one more time and see what we come up with.